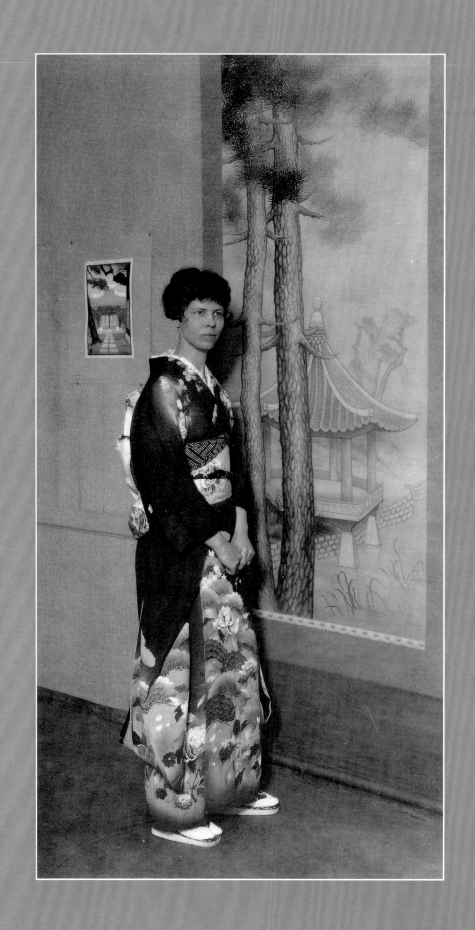

# BETWEEN TWO WORLDS

## The Life and Art of
## *Lilian May Miller*

KENDALL H. BROWN

PACIFIC ASIA MUSEUM

46 North Los Robles Avenue
Pasadena, California 91101
Tel: (626) 449-2742

This book was published in conjunction with the exhibition
*Between Two Worlds: The Life and Art of Lilian May Miller*
organized by Pacific Asia Museum, curated by Kendall H. Brown,
Adjunct Curator of Japanese Art at Pacific Asia Museum, and
presented August 19, 1998 – January 3, 1999.

Published at Pacific Asia Museum, 46 North Los Robles Avenue,
Pasadena, CA 91101. Text copyright 1998 Kendall H. Brown and
Pacific Asia Museum. Book copyright 1998 Pacific Asia Museum. All
rights reserved under international copyright conventions. No part of
this book may be reproduced in any form by any means, electronic or
mechanical, including photocopying and recording, or by any
information-storage and retrieval-system without permission in
writing of the publishers, with the exception of reviewers who may
quote brief sections in review articles.

ISBN: 1-877921-15-7
Library of Congress number: 98-065619

Produced for the Pacific Asia Museum by
Legacy Communications, Inc., Santa Barbara, California

Printed in Singapore

Designed by Roger L. Morrison, assisted by Lindse Davis

All photography for the catalog by Christopher Bliss,
Laguna Beach, except:

Figure 1, originally by K. Ogawa, Tokyo
Figure 3, originally by Genrokukan Photographic Studio, Tokyo
Figures 6, 7, Paul Little
Figure 22, originally by Murle Ogden, Honolulu
Figures 20, 21, 51, 75, 101, 104 and 105, Honolulu Academy of Arts
Figures 13, 14 and 15, The Huntington Library, San Marino
Figures 11, 34 and 65, Public Works Productions, Pasadena, California
Figures 5 and 16, Reprints by Special Collections, Vassar College
Libraries, Poughkeepsie, New York
Figure 6, Legacy Communications Inc., Santa Barbara, California
Figure 9, Kendall Brown

Cover: *Korean Junks at Sunset,* 1928, Honolulu Academy of Arts,
CATALOG 85.
Inside front cover: *Rain Blossoms, Japan, B,* 1928, Private Collection,
CATALOG 84.
Inside back cover: *Rain Blossoms, Japan, A,* 1928, Scripps College,
CATALOG 83
Frontis: Lilian Miller in kimono at Nicholson Gallery, April 1930,
Huntington Library, CATALOG 6.

# Contents

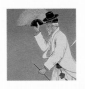

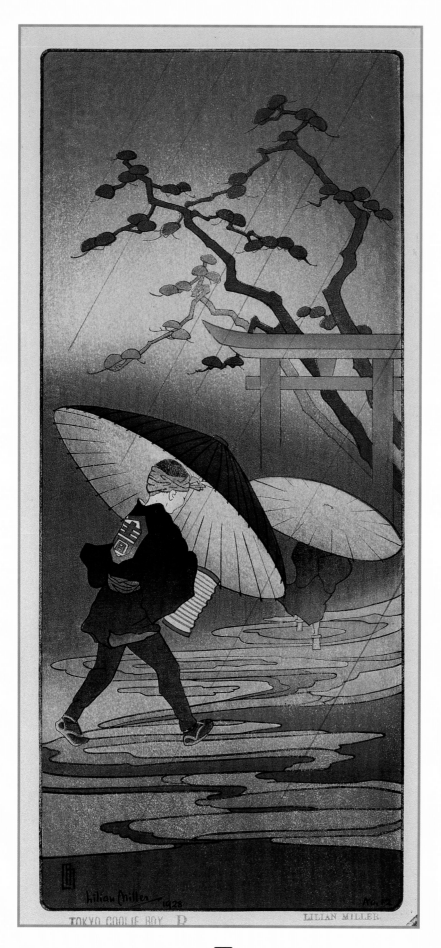

**Figure 44**
*Tokyo Coolie Boy, B*
(blue sky), 1928.
CATALOG 54

# DIRECTOR'S FOREWORD

LILIAN MILLER WAS A WOMAN WHO, in the early decades of this century, lived in Japan and Korea and was radically impressed by what she saw. Like contemporaries such as Paul Jacoulet, Elizabeth Keith, and Theodore Wores she in turn based her entire oeuvre on her Asian experience.

Lilian Miller came from a relatively prominent segment of American society. Her father was a member of the diplomatic corps and when living with her family in Japan she became fascinated with not only Asian landscape, but particularly with the fine arts. She admired the woodblock process and its results and came to not only design woodcuts, but also to carve her own blocks for their production, a most unusual practice for a Western artist. Lilian Miller's work is admired not only for its character, but for her masterful use of light and dark as well as for the color choices she made in producing her woodblock prints.

Of particular interest to the staff of Pacific Asia Museum is the fact that Lilian Miller was a good friend of Grace Nicholson, the original owner/builder of the museum's Imperial Palace-style building. In fact, in April 1930 this building hosted Miss Miller's first exhibition of woodblock prints on the Pacific coast of the United States.

I would particularly like to thank Dr. Kendall Brown for the outstanding job he has done on the essays in this catalogue. He has been responsible for unearthing a tremendous amount of new information about Miss Miller. I would also like to thank Mr. Richard Miles for initiating the idea for this exhibition some years ago and for pursuing it to fruition. Dr. Brown has already thanked the lending institutions and individuals who have been helpful in his research and I would like to echo his thanks.

I would also like to extend my gratitude to Dorothy Roraback, Meher McArthur, Michele Johnston, Marcia Page, Betty Wan, Bill Thayer, Steve Vargas, Paul Cisneros and Anita Nagrecha who are among the Pacific Asia Museum staff who have worked on this project.

David Kamansky
Executive Director and Senior Curator
Pacific Asia Museum

7

# AUTHOR'S
# ACKNOWLEDGMENTS

THIS EXHIBITION AND CATALOG are the result of the work and generosity of many individuals. First, the following persons kindly offered access to works by Lilian Miller and information about her housed in their institutions: Bruce Coats, Professor of Asian Art History, Judy Harvey Sahak, Denison Library, and Kirk Delman, Registrar, Ruth Chandler Williamson Gallery at Scripps College; James Mundy, Director, Francis Lehman Loeb Art Center, Nancy MacKechnie, Special Collections, Andrew Watsky, Professor of Japanese Art History, Willa McCarthy, Alumna House, and the staff of the Office of Academic Records at Vassar College; Rose Sharp and Chris Morrison, Phillips Library; Jennifer Saville, Curator Western Art, and Pauline Sugino, Assistant Registrar, Honolulu Academy of Arts; Jennifer Watts, Photo Archivist, Huntington Library; Pat Lynn, Library of the National Museum of American Art; Bruce Kirby, Assistant Archivist, Smithsonian Institution Archives; Helena E. Wright, Curator Graphic Arts, National Museum of American History; Robert Rainwater, Curator, Spencer Collection—Miriam and Ira D. Wallach Librarian of Art, Prints, and Photographs, The New York Public Library; Joan Wetmore, Assistant Director, The Print Center, Philadelphia; Frances Carey, Department of Japanese Antiquities, The British Museum; Linda Johnson, Department of Special Collections, University of California, Davis; and Helen Merritt, Professor Emeritus, University of Northern Illinois.

Equally critical was the information provided by Lilian Miller's nephews Morgan Cooper and Ransford Cooper, and by her niece Amelia C. Dupin. In addition, Philip Roach, Robert Muller, Bill Stein, Peter Gilder, Daniel C. Lienau, Charles Vilnis, Pat Albano, and Roger Genser helped uncover material on the artist or showed the way to those who could do so. Saskia Benjamin, Yun Cai, Susan Kahn, Karen Lansky, and Karen Weldon—graduate students in a 1997 University of Southern California seminar on female Orientalist printmakers—greatly helped the author conceptualize many issues in regard to gender, Orientalism and identity. Richard Miles served as editor, muse and mentor from the project's beginning to its conclusion. The exhibition and catalog are immeasurably better for his help.

Most of all, the exhibition would be impossible without the foresight of these lenders in preserving or gathering Miller's work and then agreeing to share it: Scripps College; Amelia C. Dupin; private collections; The Honolulu Academy of Arts; The Huntington Library; Patricia Lee Myers; Lucille Lee Roberts; The Phillips Library, A Division of the Phillips-Morrison Institute of California; and Nabil Sejaan.

I also want to thank David Kamansky, Executive Director and Senior Curator of Pacific Asia Museum for inviting me to curate this important exhibition. I would also like to thank Meher McArthur, East Asian Curator, Pacific Asia Museum, and Dorothy Roraback, former Assistant Curator, Pacific Asia Museum, who have been most helpful to me in coordinating aspects of the catalog and the exhibition. It is a privilege to contribute to this important institution's innovative series of exhibitions on Western artists active in Japan.

**Figure 45**
*Father Kim of Korea*
(blue background),
1928.
CATALOG 56

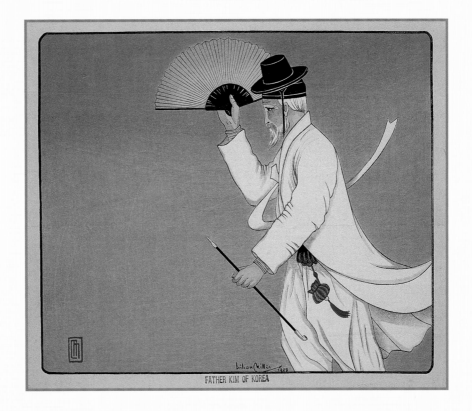

FATHER KIM OF KOREA

# PREFACE BY RICHARD MILES

A MILLER PRINT SOMETIMES makes me think of Ray Charles' version of "It's Not Easy Being Green." It cannot have been easy being Lilian Miller, as Kendall Brown's monograph makes clear. Not easy, but a triumph of heroic will against the received wisdom that women are marginal viewed through the often rheumy eyes of art history.

During the first third of this eventful century, a group consisting of three ladies and one woman put the lie to this supposed truism. Helen Hyde was arguably first to produce "Shin-hanga," or "new prints" in 1901 in Japan. Bertha Lum and then Elizabeth Keith followed with their unique styles, going where males were not welcome to depict parts of Asia unknown to the West. Finally, perhaps the toughest of them all, "Jack" Miller cut her own blocks and printed her visions as the only one of her sex who could claim to predate and even surpass in originality and imagination the "Sôsaku hanga" (so-called "creative prints") artists like Onchi, Saitô, and their circle in Japan.

I came late to Miller, after much study of Hyde, Lum, and most particularly Elizabeth Keith and Paul Jacoulet, all of whom historically brought a fresh eye to the often contentious history of East and West. Miller, whose surviving works are much fewer than Hyde, Lum and Keith, may be the strongest due to the innovative directness of her style. These are not postcards from the Orient, but pieces of a tough artist's heart. They are destined to survive.

9

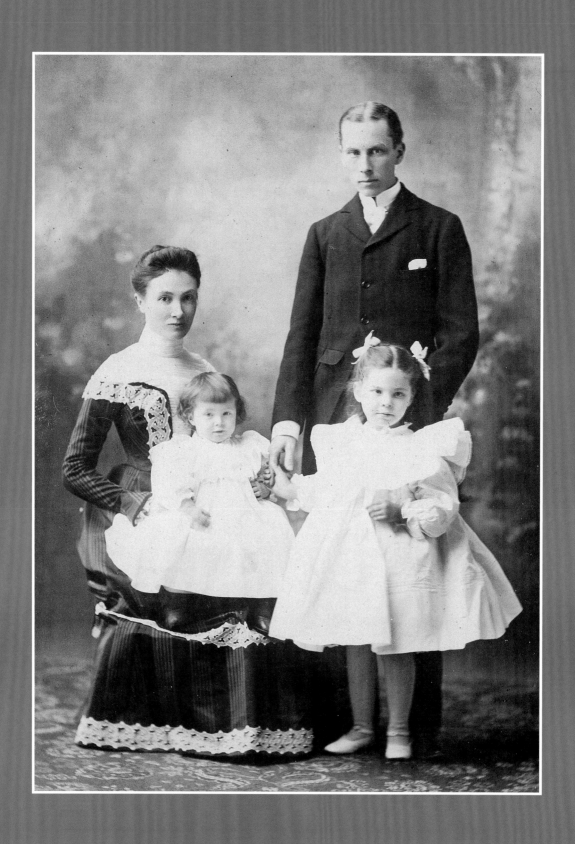

# LILIAN AND JACK:

## Negotiating Identity East and West

### TO SPAN THE GAP

*Today I try to work just as a Japanese would have worked a hundred years ago, with this difference: I have had to learn to be artist, cutter and printer all combined. It is difficult for the Japanese to understand why I do all the processes myself. So I have to explain that in our country there are no cutters and printers, and artists must do their own work. To meet this condition I must do mine. I feel, somehow, as though I were between two fires, as in Japan an artist demeans himself by doing the technical labor. But I do not regret. One must be a pioneer, a bridge, to span the gap from west to east....*

*Sometimes it is difficult to be a messenger between east and west. Sometimes one falls in the gulf between. But always I have those fine old Japanese prints before me, beckoning me down far roads to "lands of jade" where only the celestials wander at ease. If in my own work I may bring to our shores this fine flavor of an ancient art and help to widen and enrich our American outlook on the whole world of art, the bridge will have been built, however humbly.*[1]

*Figure 1*
Miller family
(Ransford, Lily,
Harriet [on lap],
Lilian),
November 1899.
CATALOG 1

ILIAN MAY MILLER (1895-1943) lived a border life on the penumbral edge of two cultures. As her words suggest, in Japan she was the foreigner who attempted to keep alive "a really fine old craft" in the age of the machine. To America, even more a land of industrialization, she sought to convey the beautiful spirit of Asia. Publicly, she desired to span the cultures of East and West, and in so doing earn her livelihood. Privately, Miller fashioned her identity at the interstices of Orient and Occident. In Japan, she was—as all non-Japanese must be—a foreigner, but with the difference that she was eerily familiar with Japanese ways. In America she was or claimed to be "Japanese"—wearing a kimono on her 1929 lecture tour—but with the difference that she was an Anglo woman of social standing. Miller was a stranger in the land of her citizenship: all but one of her adult years in America were spent at the end of her life, first

in Honolulu—perched between Asia and America—then at the edge of the continent in San Francisco. In her native Japan, despite the intimacy of her knowledge of the land, language and customs, Miller was always an outsider by nature of her race and by her primary affiliation with other foreigners. American but not really American, not Japanese yet somehow Japanese, Miller was both contradiction incarnate, and a walking, talking reconciliation of two cultures. Truly at home nowhere, Miller lived in hotels for most of her adult life.

Miller's strategy of translation and negotiation extended from national, racial and cultural affiliation to gender and sexual orientation. An unmarried, financially independent and creative woman, Miller transgressed the standard sexual, economic and social roles accorded women. Yet, despite the heterodoxy of her activity, the style and content of Miller's art are far from transgressive: her lyrically naturalistic prints and watercolors of Japanese or Korean figures and landscapes often parallel the romantic view of Asia at the heart of Orientalist discourse. Similarly, while life in the Orient allowed Miller a measure of freedom from the more circumscribed roles possible in America, and simultaneously bolstered her opportunity for success as a professional artist, these threats to standard gender roles were modified by her self-presentation in kimono—the ultimate symbol of femininity—during her 1929-30 American lecture tour. Even as Miller presented herself as the kimono-clad savior of traditional Japanese craft, her success was due in large measure to her use of a network of progressive women who served as patrons, dealers and publicists. Miller's play of identity is expressed in her names: "Jack" to family and friends, "Lilian" on her prints. In public, on the printed page or in person wearing kimono, she was Lilian: the tongue tickling the palette three times. In private, often in slacks, she was plain Jack. Jack and Lilian—the names almost serve as tropes for Miller, a disinvestor and reinvestor of cultural norms with the translucent cloth of culture.

Homi Bhabha cautions that while claims to modern identity are based on "race, gender, generation, institutional location, geopolitical locale, [and] sexual orientation," it is crucial to "focus on those moments or processes that are produced in the articulation of cultural differences. These 'in-between' spaces provide the terrain for elaborating strategies of selfhood. . . ."[2] Miller's negotiation of the spaces of West and East, insider and outsider, male and female, heterosexual and homosexual, simultaneously reinforces these binary polarities and suggests their bridging. The careers of Western artists depicting the Orient and adapting (pseudo-)Oriental styles constitute such articulations of selfhood through cultural difference. Thus, the deployment of the Orient—as the basis for a critically and commercially successful career, as a place which nurtures and masks homosocial and perhaps homosexual identities,[3] and as the space which renders culturally dominant the otherwise subaltern—helps illuminate Miller's own life and art as well as those of such contemporaries as Helen Hyde, Bertha Lum, Elizabeth Keith and Paul Jacoulet whose careers as Orientalist print artists parallel Miller's as much as they diverge from it.

This essay explores Lilian Miller's life as it may be pieced together from what she wrote and what others wrote about her. It suggests some conditions for the creation and reception of her work as well as how that biography—both real and constructed—served to color Miller's art. The second essay analyzes the subject and style of Miller's print art to determine some of the ways in which this artist, in an age of imperialism, negotiated colonial or Orientalist ideology, class, culture and gender. At the same time that Miller's intentions may be inferred from her art and writing, some readings of her work are examined to ascertain the ideological spaces in which her visual and verbal texts had meaning for her contemporary Western audience in Japan and America. Thus, the goal in these essays is not simply to find meaning in the "texts" of lives, poems or pictures, but to approach the meanings that reside in those spaces around them.

## A Most Unusual Childhood

WHILE LIVING IN SAN FRANCISCO's HOTEL EL DRISCO in 1940, Miller produced a four-page pamphlet promoting herself and her art. In the third paragraph, she wrote:

> *Hers was a most unusual childhood, spent as it was close to the grandeur of Nikko shrines and bold mountain landscape, to pine-topped granite walls of the old Imperial moats in Tokyo or happily visiting in the quaint and busy streets of the capital, with their singing vendors, their multi-colored lanterns, recalling the scenes made famous by Hiroshige. Aesthetic environment, choice of a calling in a land where the artist is second only to a member of the priesthood, austerity of training, all helped to mold and shape this artist's finely spiritual interpretation of the beauty of the natural scene about her.*[4]

Miller was adamant that her artistic temperament was shaped by her upbringing in Japan, and despite the hyperbolic, romantic and self-serving nature of her self-definition, Miller's childhood was indeed most unusual. Among Western artists who lived in Japan and specialized in Oriental subjects, Miller was the only one born in Asia.[5] For most other Orientalist artists, Asia was a personal discovery and thus often a rejection of the values of their parents and the society in which they were raised; for Miller, the project of making Asia into art grew from the interests of her father, Ransford Stevens Miller.

Ransford Miller was one of the United States' most seasoned "Asia hands" in the early twentieth century. Born in Ithaca, New York on October 3, 1867, upon graduating from Cornell he went to Japan to serve as secretary to the International Committee of the YMCA. By 1895 he had joined the American Embassy in Tokyo and married Lily Murray, a young woman from Lockport, New York who took a post as an English teacher with a Christian mission in Tokyo in 1888. The newlyweds quickly started a family (figure 1) with the birth of Lilian May on July 20, 1895 and Harriet Hartmann on October 2, 1898. Lilian was partially named after her mother—Lilian May expanding the surname then contracting the family name of Lily Murray—but Ransford apparently wanted a male heir as Lilian was nicknamed "Jack" and Harriet became "Hal." Lilian inherited the fun-loving and robust personality of her father, adopting his interests in "mountain climbing, bird and game shooting, swimming."[6] While Lily picked up only basic Japanese, Ransford immersed himself in the language and culture. In an account of the American diplomatic corps in Japan around 1900, William Sands describes how Ransford Miller was called "the 'Japanese secretary' because he read, spoke and wrote Japanese, but under our system he was out of line at that time for promotion, though he was the only one of us who knew fluently the language in which our business was conducted."[7]

Given his own passion for Japanese culture, Ransford encouraged his young daughters to follow suit. In 1904, at age nine, Lilian enrolled in the *juku* or private teaching atelier of Kano Tomonobu (1843-1912), ninth head of the Hamachô line of the prestigious Kano school. Tomonobu, who studied the synthetic styles of the great Meiji painters Hashimoto Gahô (1835-1908) and Kano Hôgai (1828-88) as well as oil painting and watercolor with the Yokohama resident Charles Wirgman (1832-91), taught at the prestigious *Tokyô bijutsu gakkô* (Tokyo Art School) and also took private students including from 1900 the Austrian Emil Orlik (1870-1932) and American Helen Hyde (1868-1919). Perhaps on Hyde's suggestion, Lilian Miller entered the *juku* where, by one account, she learned rapidly. In a 1930 letter Harriet Miller Cooper recounts how Tomonobu assigned a weekly subject then judged the results on a scale of 60 to 100. Although a beginner Lilian received the plum branch, a subject requiring "strength and vigor in the stroke making the branch, and delicacy and precision

in the portrayal of the flowers." The following week Lilian submitted but a single sheet. Although disappointed at first, the elderly master soon grew delighted in the sketch, placing "a small 100 in the upper corner in red ink. Then, crossing this out, he placed in its stead a Japanese character unknown to the child. Turning to her with a smile, he said, 'At first I marked this 100; but it is more than that, it is perfect.'"[8]

In 1907, after several years with Tomonobu, the 12 year-old Miller entered the *juku* of the younger and somewhat more progressive Shimada Bokusen (1867-1941), another Hashimoto Gahô student with connections to foreigners. Bokusen, a member of the *Nihon bijutsuin* (Japan Art Institute), had previously taught traditional brush painting to the American Henry Bowie (1848-1920). Miller's training preceded quickly because in 1907 she exhibited a painting in the Imperial Salon at the Ueno Academy of Fine Arts. In March 1909 Bokusen formally awarded her with the *gô* or art name *Gyokka* (Jeweled Flower) in recognition of her artistic accomplishment demonstrated in an album of four flower paintings (figure 2).[9] Rendered in ink and color, the four works are conservative in the extreme, exemplifying the *rinmo* (copying of established subjects and styles) central to formal artistic training and evaluation. Although the Kano school often required about ten years of study before the master awarded a *gô*, more progressive schools instituted greatly accelerated two-year courses of general study. Miller may well have received special treatment as a foreigner and a female—her gender acknowledged in the sobriquet *Gyokka joshi* (Miss Jeweled Flower) signed on each picture—yet the paintings demonstrate the technical proficiency prized in Japanese ateliers. In her brief unpublished biography of Miller, print dealer Elizabeth Whitmore recounts the artist's own description of two years working "like a galley slave" under Bokusen.[10]

**Figure 2**

*Flower Basket*, ink and color on paper, 1909.

CATALOG 25

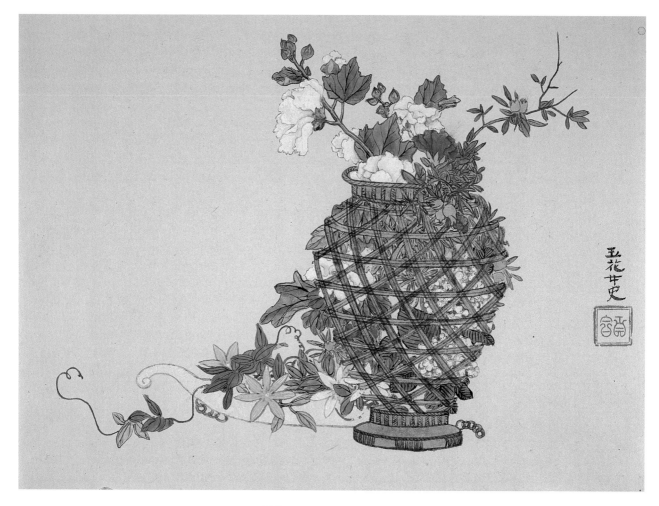

**Figure 3**
Lilian Miller
on back of her
Japanese maid,
ca. 1896.
CATALOG 2

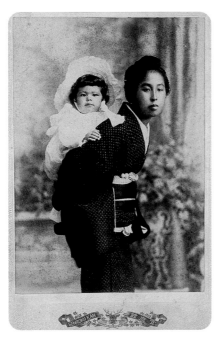

Miller proudly acknowledged her strict training under prestigious Japanese masters, but also presented her eventual career in prints as the natural outgrowth of her exotic childhood in Japan. During a 1929-30 lecture tour of the United States, Miller told how as a small girl she, chatting in the language of her Japanese *amah* (figure 3), explained that in America young girls played with paper dolls. The next day the maid brought an "armful of colorful pictures. The child contentedly spent the day cutting out the figures from the pictures." Years later, a grown woman living in Tokyo, she went to a Tokyo exhibition of ukiyoe prints by old masters and realized that one print was the very design she had joyfully scissored into a doll.[11] Through the stories of years laboring under Japanese masters and of a childhood cutting dolls from ukiyoe prints, Miller created a biography which naturalizes her eventual mastery of Japanese prints, and buttresses her claim to defacto Japaneseness. This self-construction is most obvious in an unpublished biographical account based on Miller's own words:

> *Like Japanese children who breathe in beauty with their first breath Miss Miller has given the accident of her birth as reason for her early interest in art. . . . Part of each year of her early life was spent at Nikko, where, and at Chuzenji, the diplomatic set were in the habit of spending their summers. In the atmosphere of the loveliness of this mountain area with its century old temples of ornate beauty it seemed natural for her "to slop around" with brushes and paints.[12]*

## YOUR "BOY" JACK

**M**ILLER'S STUDY WITH BOKUSEN ended in 1909 when her father was transferred to Washington to become chief of the Division of Far Eastern Affairs at the State Department. Although childhood photos show Lilian with a cropped boyish haircut, she now grew her hair long in the fashion popular with American girls (figure 4). Despite the femininity evident in the posed studio photograph (apparently for her parents), she signed it: "Your 'boy'—Jack." The spirit of the inscription is manifest in the signature's powerful cross-stroke for the upper-case "J," the taut check for the second stroke, and the flamboyant flourish after the "k." A graduation photo (figure 5) from Western High School in Washington DC reveals that by her senior year Miller had cut her hair short—a style she would wear for the rest of her life. A favorite family story tells of seventeen year-old Jack's decision to go to Vassar College in New York.

15

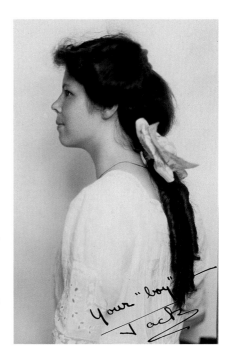

**Figure 4**
Lilian Miller
ca. 1910.
CATALOG 3

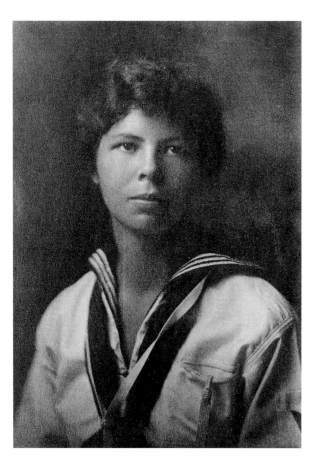

Ransford, aware of the financial difficulty this would entail but also encouraging of his daughter's independence, gave one condition: Jack must first prove mastery of the feminine arts by preparing and serving dinner for family and guests. When the date arrived, and Jack had made the meal, her father called to say that an urgent matter would keep him at the office. Nonetheless, the dinner went ahead; and in September 1913 Jack went to Vassar.

Most accounts of Miller's life pass quickly over the four years at Vassar, noting her 1917 graduation with a Bachelor of Arts degree. Whitmore's biography, *The Evening Star* article of 1929, and a 1940 article all state that in college Miller never once seriously held a brush as her father feared her "pure Japanese touch" would be spoiled by Western methods. Despite later claims to artistic purity, Miller did create art in college. A program for the 1914 Vassar production of *A Midsummer Night's Dream* (figure 6), bearing Miller's stylized LMM monogram, reveals Miller's work in pen rather than brush. Other than the monochrome palette, the picture resembles nothing she could have learned from Tomonobu or Bokusen. Instead the dramatic position of the tree, fluid drawing and meticulous delineation of the leaves reveal Miller's imitation of Arthur Rackham's (1867-1934) illustrations for a 1908 edition of Shakespeare's play.[13] The drawing of a fairy, perhaps the changeling Puck, is cribbed from Rackham altering only the hat and foliage. The pixie may well stand for the impish and high-spirited eighteen-year-old Jack Miller.

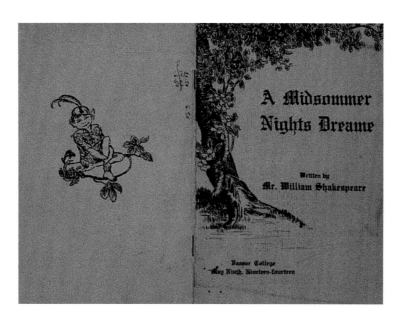

**Figure 5**
Lilian Miller highschool portrait, ca. 1913.
CATALOG 4

**Figure 6**
Illustrated program for *A Midsummer Night's Dream*, 1914.
CATALOG 32

Another pen drawing from the same year, also with the LMM monogram, discloses more of the artist's mental state as a freshman. Executed on a standard sheet of paper it presents a view through a latticed Japanese window past a large tree and across a bay over which Mt. Fuji rises majestically. The scene may well be from an inn at Hayama, a small town on the Izu peninsula with spectacular views of Fuji and a favorite vacation spot for the Miller family during their Tokyo years. The drawing's function as a statement of Miller's response to the new circumstances of life at Vassar is suggested through a poem by her classmate Edna St. Vincent Millay (1892-1950) neatly calligraphed on its back:

> *What calm composure will defend*
> *your rock; when tides you've never seen*
> *assault the sands of what-has-been*
> *and from your island's tallest tree*
> *you watch advance What-is-to-be?*

> *The tidal wave devours the shore*
> *there are no islands any more—.*

Millay, the best-known female poet of her generation with the publication of *Renascence* in the year of her graduation, was already a practiced poet upon her matriculation to Vassar in 1913. This unpublished poem's meditation on maturation and socialization surely appealed to Miller as she adjusted to life both in America and away from her family.

Moreover, Millay's bohemianism—which after graduation would evolve into public calls for sexual emancipation, bi-sexuality and open marriage—may well have found an eager audience in Miller. Millay's own masculine nickname "Vincent" and use of the male pronoun "he" when referring to herself paralleled Miller's self-construction as "Your 'boy' Jack." Although no evidence of a friendship between the women has come to light, in a freshman class of 300 they surely knew of one another. Furthermore, because Miller's course of study also emphasized literature—including elective classes in nineteenth-century English poetry, the English Classic and Romantic movements and contemporary French literature—they almost certainly took courses together. The later lives of both women demonstrate William Drake's statement that "The women poets between 1915 and 1945 were moved by a growing recognition that the kind of empowering, liberating love—friendship in Spencer's sense—was the necessary root of their creative development."[14] Given the content of Miller's own poetry, there is a strong possibility that she took Millay or some other strong-willed young woman as her model at Vassar.

**17**

## IN A KOREAN PALACE GARDEN

DURING HIS ELDER DAUGHTER'S COLLEGE YEARS, Ransford Miller was selected to serve as American Consul General in Seoul, Korea. Upon graduation Lilian left her younger sister Harriet, then in her second year at Vassar, for an extended visit with her father and mother at their new residence. Despite the deep impression left by this first experience in Korea, she returned to the US for a government job arranged by her father. Lilian Miller started work on September 13, 1918 as a secretary, with a secondary post in distribution of political intelligence, in the Division of Far Eastern Affairs. With the country engaged in the First World War, the patriotic graduate may have entered with dreams of serving her country. However, when the war ended, and with an annual salary of but $1,020, she quit on October 15, 1919.

Miller then returned to Japan where she studied again with Shimada Bokusen. *The Evening Star* article of 1929 claims that Miller "picked up the thread of her neglected work as if it had been left off the day before." Harriet Miller tells a more credible if somewhat melodramatic story in a 1930 letter:

> *When, after school and college, she returned to Tokyo to resume her art studies, her teacher Mr. Shimada had become one of the best-known teachers and artists of Japan. So great a teacher takes but the most promising of the pupils who ask for his training. He placed all prospective pupils through a hard oral test, and a rigorous test of their command of the brush as well. He asked Lilian to bring him four sketches at the end of the week that she considered had merit. She worked hard at the now unaccustomed task. She chose three or four colorful studies, but not quite content, she placed a fifth study in black and white at the bottom of the pile. When she offered them to her teacher, he seemed unimpressed. She feared she had failed her test. He flipped off one sketch after another, with barely a glance at each. As he started to gather the papers, he said: "Here, what's this?" He noticed there was one more than he had asked for. He studied it. It was a study of a single frond of bamboo. But the wind was bending it in a gentle arc. He took her as his pupil, and helped her to win high honors in her chosen field of Oriental art.*[15]

Miller's ensuing period of rigorous study with Bokusen resulted in her first artistic triumph. A sketch (figure 7) made during Miller's initial year-long sojourn to Korea of 1917-18, was turned into the huge ink painting *In a Korean Palace Garden* (figure 8). In 1920 it was entered in the Imperial Salon *(Teiten),* the newly established exhibition of the Imperial Academy of Fine Arts *(Teikoku bijutsuin)* which in 1919 replaced the Ministry of Education Art Exhibition *(Bunten)* as the premier exhibition for Japanese painters and sculptors. Of the roughly 500 hundred competitors, virtually all of whom were Japanese and male, Miller was one of five artists honored with the *tokusenjō* (award of special merit) or "golden scroll." The award bestowed on the painting—also called *The Queen's Pavilion, East Palace, Seoul, Korea*—was often touted in later American articles not merely as proof of Miller's acceptance by the Japanese but of her authenticity as a "Japanese artist." *The Evening Star* article, for instance, brags: "Miss Miller is the only foreign artist since 1890 who has competed in exhibitions open only to native Japanese. She is regarded in Japan as a representative Japanese artist."[16] The Japanese judges were likely impressed by the young American artist's skillful brushwork and dramatic composition. However, Miller's status as a foreign women was not hidden but clearly manifest in her Japanese signature *Hokubeijin Gyokkajo* (North American Jeweled Flower Woman) and seal *Hokubei Gyokka* (Jeweled Flower of North America). Moreover, the *LM Miller* signature and *LMM* seal clarify the nationality of the artist even as they demonstrate her bi-culturalism.

**Figure 7**
*In a Korean Palace Garden,* ca. 1918, graphite on paper.
CATALOG 33

For Japanese viewers in 1920 this painting by an American, the daughter of the Consul General in Seoul no less, depicting a peaceful scene in a Korean royal garden would have subtly underscored their government's claim to peaceful and benevolent rule in Korea—Japan's first and most important continental Asian colony. Not surprisingly the painting was exhibited by the government in Seoul in 1921 and awarded a gold medal. Perhaps Korean viewers realized that the moon-viewing pavilion in the painting was that of Queen Min, killed by Japanese agents in the coup d'état of 1895. Any overt political implications in the work are unlikely: as a diplomat's daughter and highly-educated young woman, Miller surely knew of Japan's history in Korea, yet this work and her many subsequent prints of Korea emphasize the "Quaintness of Korea" (the title of one work)— an image appealing to Westerners and Japanese alike. In a 1921 letter, Harriet Miller comments that beyond its technical skill, the appeal of the painting was that "The subject—Korean—was as new to the Japanese artists as it was to the foreigners."[17]

Reportedly the success of the painting so impressed Bokusen that he offered to bestow a new artistic name on Miller and make her second in line to head his atelier; given the stylistic conservatism this would entail, Miller refused.[18] Despite the acclaim awarded the painting, such works did not fetch high prices relative to the time required to make them. Thus Miller also produced more commercially viable and quickly-rendered paintings. The two-panel screen *Bamboo in Snow* (figure 9) exemplifies Miller's screen production from 1920. Although more decorative than *In a Korean Palace Garden* and far more rapidly brushed, this type of work apparently found neither critical nor commercial favor. In September 1920 Miller turned to the production of woodblock prints, looking to make a living as well as a name in art.

**Figure 8**
*In a Korean Palace Garden*, 1920, ink on paper.
CATALOG 26

19

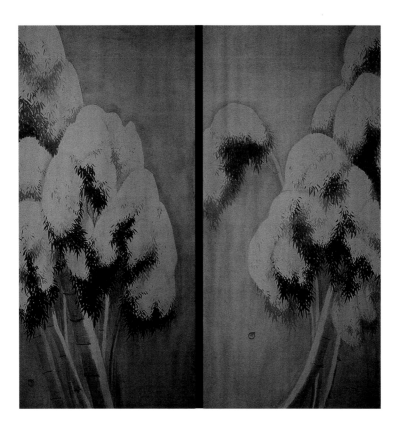

**Figure 9**
*Snow on Bamboo,*
1920, ink
on paper.
Vassar College

## A STORY-BOOK LAND

THE EARLIEST EXTANT ARTICLE ON MILLER'S PRINTS reveals how the artist was received by at least some of the audience who bought her work. John Stewart Happer's "Art and Crafts, Modern Wood Engraving and Colour Prints," published in *The Far East* magazine on May 28, 1921, reviews the evolving *shin-hanga* movement in Japanese prints, detailing how the publisher Watanabe Shôzaburô worked with such artists as Kawase Hasui, Ito Shinsui and Yamamura Toyonari to update the old ukiyoe print tradition. In the article's last paragraph, Happer writes: "Not only, however, are the Japanese reviving the art. It is a source of congratulation to Americans that there is a young American woman who is vying strongly with the Japanese, using the same technique and achieving a great measure of success." He locates the legitimacy of Miller's foray into woodblock printing in her birth: Miller was "born in Tokyo, and so may claim to be a Yedokko [native Tokyoite] and entitled by place of birth to the artistic heritage of the Ukiyoye School."[19]

Happer attributes Miller's immediate success among the "small circle of print lovers in Tokyo" to the quality of the prints produced by Miller's engraver Matsumoto and printer Nishimura as well as to the picturesqueness of the Korean subjects. The latter point is the subject of "American Girl Depicts Spirit of East Through Color Prints, Miss Lillian [sic] ('Jack') Miller, Daughter of Consul-General in Seoul, Finds Korea a 'Story-Book Land,'" published in *The Japan Advertiser* on January 28, 1922. Miller is said to have produced more than 6,000 prints and holiday cards (figures 10 a-h), purchased by "art lovers in Peking, Shanghai, Tokyo and Seoul" as well as people in the "larger American cities," her work having recently been shown in New York and Boston, where she was elected to the Boston Arts and Crafts Society. Her, "formal presentation to the Americans and foreigners in Tokyo" started in December 1920 at the home of Mrs. Charles Burnett, wife of the American Military Attaché in Tokyo, when Miller showed screens and woodblock prints. She also presented a screen to the Empress and sold 2,000 prints including cards.[20]

20

**Figure 10 a**
*An Orange-Sailed Korean Junk,* undated.
CATALOG 35 a

**Figure 10 b**
*Korean Man on Donkey,* 1923 card.
CATALOG 35 b

**Figure 10 c**
*Korean Man Smoking Pipe,* undated card.
CATALOG 35 c

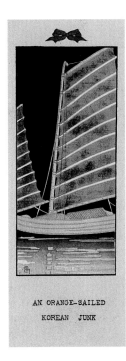

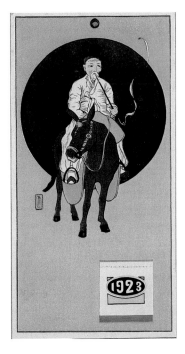

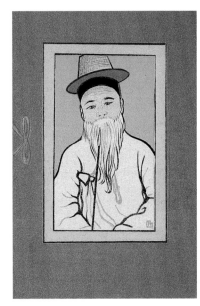

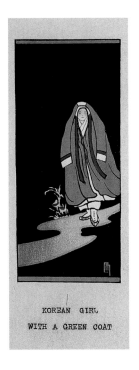

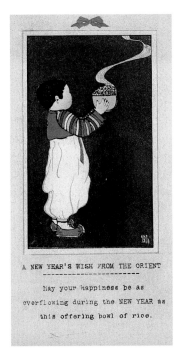

**Figure 10 d** *Korean Girl with a Green Coat,* undated card.
CATALOG 35 d

**Figure 10 e** *Korean Boy Holding Rice Bowl,* undated card.
CATALOG 35 e

**Figure 10 f** *Korean Spirit Posts,* undated card. CATALOG 35 f

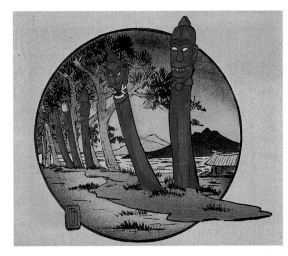

21

**Figure 10 g**
*Korean Woman Walking in Snow,* undated card.
CATALOG 35 g

**Figure 10 h**
*"The Crescent Moon Rides Low," Korea,* undated card.
CATALOG 35 h

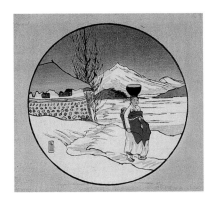

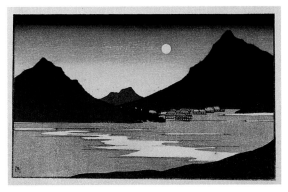

Indeed Miller's 14 woodblock prints produced in 1920 and 1921 gained attention well beyond Tokyo. On Sunday August 12, 1923 *The San Francisco Examiner* devoted nearly an entire page to Miller's prints beneath the banner headline "Vassar Girl Portrays Hidden Beauty of Korea in Color." Under the hyperbolic sub-heads "Lillian [sic] Miller, Daughter of U. S. Consul General, Produced Prints That Rival Those of Japanese Masters" and "She Is The First Artist of White Race To Draw Inspiration From Oriental Beauties Of The Hermit Kingdom," Nadia Lavrova describes the charm of her depictions of Koreans and the vigor of this "slim boyish girl." First she reveals that Miller's "mission in life. . . [is] to portray the hidden beauty of the Hermit Kingdom." She continues:

> *It is a pleasure to watch this energetic young woman, full of vitality and imbued with the joy of life, give a shake of her bobbed curls and start every morning to her little Tokyo workshop. For Miss Miller lives now in Tokyo, where she can get the commodities needed for her work, and where a constant flow of tourists passes to and fro. She occupies a dainty Japanese studio and paper house, where a doll-like amah keeps house on a strictly Japanese basis. That is such superfluities as beds, furniture and square meals are unknown and unwanted. If you start to argue about it with Lilian, she will state you her reasons either in Korean, Japanese or American, according to the mood she is in. Still, there is one thing she clings to in all senses of the word—these are her golf clubs. After two hours spent on the links or in other light athletics, she returns to her Japanese studio to work. . . .*[21]

Lavrova clarifies the economic interest which also inspired the artist: "Lilian Miller sells her prints, make no mistake about that. For all her dreams she is a very independent young woman, bent upon providing for her own needs." In addition to selling her prints to "foreign tourists who use them to recall through them the fascination of the Orient," Miller also cultivated patrons in the diplomatic community through two exhibitions in the American Embassy and at the expatriate resort town of Karuizawa. She accompanied each print with a brief narrative describing the scene. Most of these text panels include a pen drawing in the dreamy, imprecise style of popular illustrator E. H. Shepard.

Because her print production was founded on the desire to become financially self-supporting, Miller's self-publication was unique among Western print artists in Japan in 1920. While Elizabeth Keith and Charles Bartlett worked with the *shin-hanga* publisher Watanabe, Miller's knowledge of Japanese and familiarity with the Tokyo art world likely explain her success in finding the carver Matsumoto and printer Nishimura Kumakichi II. Furthermore, Miller's connections in the diplomatic community provided a base of clients even as her outgoing personality won press coverage and the expanded distribution which followed. These articles reveal Miller's self-construction as both a modern American girl—financially independent, living on her own in a great city, playing golf, and sporting bobbed curls—and the traditional Japanese artist—devoted to her art after years of training with respected masters. In the exotic setting of the Far East, Miller was liberated from the expectations of marriage and motherhood which shackled other women of her generation. Yet, her transgressive act of complete independence is excused because her art is not about masculine subjects but rather is devoted to the quaint, traditional and feminine Orient. In sum, Miller substitutes Asian "tradition" for the Western traditions she flaunts.

Miller's prints were based largely on sketches and paintings made in Korea. A letter by Harriet, written on a visit in the summer of 1921, tells how Lilian—living in a small two-story house in a Tokyo suburb—employed painting and photography to prepare her prints:

*Last winter when it was so cold and the snow so deep in Korea she would have to blow on her hands between each stroke of her pencil in sketching. She took to getting her views with her camera and remembering the colors only. . . .She works hard to get the line and balance of her picture just as she wants it before she takes the photograph. She very seldom copies a photograph exactly—but she adapts a subject which will appeal to foreigners to the Japanese style and brushwork, and gains the admiration of both foreigners and Japanese in that way.[22]*

The popular success of her first prints inspired Miller to begin the series "People We Pass," rendering "fascinating Korean types" against a black background. She also ventured into another creative form—verse. Her small volume of poetry and prints, *Grass Blades From A Cinnamon Garden,* was in press in Tokyo and the author visiting her parents in Seoul when the Great Kantô Earthquake struck on September 1, 1923. In the conflagration after the tremor, Miller's book was destroyed as were many finished prints, their blocks and her studio. At this time Miller fell seriously ill. Whitmore attributes the malady to the shock of her loss. Family oral history specifies beriberi—a disease caused by extreme vitamin B deficiency resulting in dramatic weight and muscle loss as well as mental confusion. Miller produced no art for three years as she recuperated under her parents' roof in Seoul.

## GRASS BLADES FROM A CINNAMON GARDEN

BY 1927 MILLER WAS SUFFICIENTLY RECOVERED to rework and then oversee publication of *Grass Blades.* In 1928 she created roughly two dozen new landscape prints and reissued several of the most popular figure designs from 1920. Miller herself cut and printed the blocks for most, if not all, of these prints. At this time she also became friends with Joan Slavell Grigsby, an English poet living in Seoul with her husband. Miller not only designed six monochrome prints (figure 11) for Grigsby's 1929 poetry volume *Lanterns By The Lake,*[23] but she alone is thanked in Grigsby's

**Figure 11**
*The Temple Lanterns,* monochrome frontispiece to *Lanterns by the Lake,* 1929.
CATALOG 40

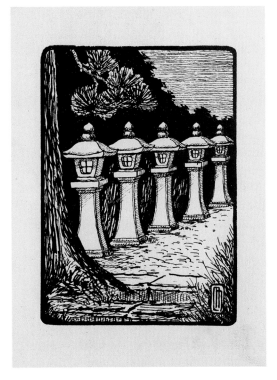

23

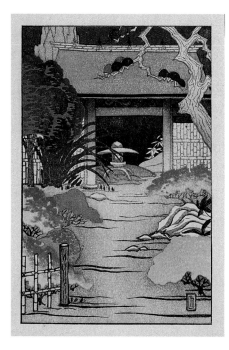 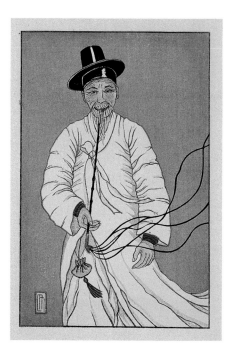

**Figures 12 a-b**
Illustrations for
*Grass Blades from a
Cinnamon Garden,*
1927.
CATALOG 39

a. *A Japanese
Garden*

b. *The Three-Foot
Bamboo Pipe*

preface for "the sympathy and critical understanding which, as a poet herself, she has given in so generous a measure to my work." The penultimate poem "A Cherry Night in Korea," dedicated "To L. M. M.," describes the artist painting the "blue Korean dusk" with the writer by her side:

> *If you should paint a picture and I a song should make*
> *For all our lives renewing*
> *This time of cherry viewing*
> *When under clustered blossoms the rosy lanterns wake,*
> *Could we regain, I wonder,*
> *This hour of faery splendour,*
> *If you should paint a picture and I a song should make?*[24]

The theme of female companionship and creative production within the nurturing realm of Oriental beauty is echoed in many poems in the book and is even more central in Miller's book of verse published two years earlier.

The poems in *Grass Blades* were likely written over the decade from Miller's initial return to the Orient until 1926. Roughly half of the poems are verbal pictures of Korea or Japan, Miller using words to create impressions of an Orient quaint, mysterious, still and pure—beyond the corruption of the modern world. Most poems are entirely visual, describing neither ideas nor even feelings. In "Brush Pictures of the Celestial Mountain," Miller evokes Mt. Fuji at dawn, morning, noon, afternoon and evening. "Dawn" reads:

> *I saw shy Fuji of an early morn*
> *Robed in an opalescent mist,*
> *Like some quaint maiden, delicate, highborn*
> *In pearl-grey kimono, cloud-kissed,*
> *Stolen away alone to greet the dawn,*
> *Thinking to see no strangers by the sea;*
> *And when I smiled and looked too eagerly,*
> *She hid her face behind a sleeve of fawn.*[25]

**24**

**Figures 12 c-d**
Illustrations for
*Grass Blades from a
Cinnamon Garden,*
1927.
CATALOG 39

c. *Palace Walls
That Crown The
Vale On Quiet Hills*

d. *The Little Shrine
On Quiet Hills*

Each of the book's four print illustrations (figures 12 a-d)—*A Japanese Garden, The Three-Foot Bamboo Pipe, Palace Walls That Crown The Vale* and *The Little Shrine on Quiet Hills* —manifests this kind of sentimental Orientalism in which the Western author "captures" the timeless beauty of the East and recreates it as a universal ideal. About half of the prints from 1928 illustrate places or scenes described in her verse.

While many of the poems are love poems to the Orient, others are far more personal meditations in which Miller pines for a love "over the western seas" or with whom some golden days have been spent in Asia. In "A Letter To A Poet" Miller speaks of her "heart in the flaming mantle of your love," the imagery of this and other poems strongly suggesting that the object of romantic interest is female.[26] In sum *Grass Blades* sings of loss—the loss of love and the implicit loss of the Orient—and the desire for repossession. The feminized Orient, alternately maternal and sexual, is easily linked to the desired lover who is at once the gentle teacher and the object of amorous desire. Thus, the Orient becomes the lover and the lover becomes the Orient, both ideal states of grace and sites of feminine creativity. Because Miller desires to immerse herself in this state of love, the poems (like most of her art from the time) contain little conflict or emotional complexity. In their place is the sensuous rapture of overwhelming desire for union with the beloved:

### NIGHTS IN JAPAN

*Nights in Japan—with what damp, heavy veils
    Of perfume they are wrapped! From early dusk
They waft strange fragrances, sweet spice and musk,
    Rich eastern scents, aromas from temple pales.*

*As I bend from my window to the midnight breeze,
    It is as if I leaned into the heart
    Of a great dim flower, with petals soft apart,
Letting me breathe their inmost sanctities.*[27]

Where Miller's poetry was often flat and contrived, her art was becoming increasingly radiant and natural.

## THIS JAPANESE ARTIST IS AN AMERICAN

IN 1929, WITH A BOOK OF POETRY PUBLISHED, more than thirty newly-produced prints in hand, and the draft of the co-written play *Charan* awaiting a publisher, Miller set out to present herself to the American art world after an absence of more than six years. Two months before setting sail, Miller met Grace Nicholson (1877-1948), an entreprising Philadelphian who had moved to Southern California in 1901 and gone into the wholly-original business of selling American Indian baskets. That business evolved into Oriental antiquities which led to a remarkable buying trip in Japan, Korea and China beginning on January 20, 1929. Nicholson's diary discloses that on August 18, she and her assistant Mr. Carrol Hartmann arrived in Seoul where they had been advised to contact American Consul-General Miller. Mrs. Miller was not well enough to show the city to the visitors, so her daughter Lilian took them to the museum and then around the palace grounds on the next day. The two devotees of Oriental art talked until ten pm, then met the following day for another viewing of the museum and a visit to the American Consulate.[28]

Miller's chance meeting with Grace Nicholson—beginning a relationship very advantageous to the artist's career—foreshadowed her successful tour of America in which she made full use of a network of female contacts from journalists, museum curators and art dealers to women's groups of several types. Before leaving Miller arranged for the premier exhibition of her new work at the Print Corner gallery in Hingham Center, Massachusetts, just south of Boston, under the aegis of its director Elizabeth Whitmore. Another exhibition was at the Women's Educational Union in Boston from October 18-30. The journey commenced when she and friend Helene Griffiths sailed from Yokohama aboard the Dollar Line's "President McKinley," arriving in San Francisco on October 17.[29] Miller's demonstration of the woodblock process and exhibition (with sale) of her prints was intended to revive interest in Japanese traditional arts as represented by her own work. Miller explained her purpose:

> *I am here, to make a plea for the wood-block print. It's a dynamic*
> *process. In Japan the old-time craft is being pushed to the wall by*
> *modern printing machines. In this country, while etchings have gained*
> *an established position in the cultured taste of the public, the wood-block*
> *print is as yet little known and appreciated. So I consider my mission*
> *two-fold: To do my little share toward keeping this beautiful form of artistic*
> *expression alive in Japan, and second, in introducing its merits to the*
> *American public.*[30]

Miller seems to have been generally accepted as an authentic practitioner of Japanese print art. The mid-October 1929 *Art Digest* article "This Japanese Artist is An American" states: "When the Japanese artist undertakes to work in the Occidental manner he seldom gets anywhere, but when an American woman adopts the technique of old Japan she is charming."[31] Miller is placed in the footsteps of Bertha Lum and Helen Hyde, but because of her birth and training in Japan: "Miss Miller is regarded by the Japanese as a native."

On November 12 she delivered a talk and demonstration for The Japan Society's Anniversary Dinner at Copley Plaza in Boston. Miller's extant possessions show that during her various lectures she made demonstration prints from *Hongkong Junk* and *Dwarf Plum Tree*.[45] The Gordon Dunthorne Galleries in Washington DC hosted an exhibition from November 20 to December 4. The exhibition brochure "Life in Japan and Korea," featuring Miller at work on her prints in the cover photo (figure 13), lists five print-making demonstrations with artist in "native costume." Prices range from $6 to $15 for prints produced in 1920 and 1921, and from $15 to $50 for Miller's

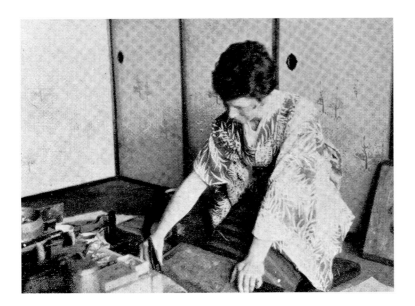

new prints—an increase explained not only by the greater size and lavishness of the recent designs but, according to the brochure, "by the fact that she does the entire process herself, that is, making the drawing, cutting the blocks and printing—which is not the case with Japanese artists, who generally employ someone else to cut the blocks and another person to do the printing." She is also credited with being "regarded [in Japan] as a representative Japanese artist," a status demonstrated by her invitation to "exhibitions open only to native Japanese."[32] Miller's image as a natural bridge between Japan and America was eagerly devoured by the local press as demonstrated in Gretchen Smith's November 21 article in *The Evening Star*. The reporter, fearing that Americans might be suspicious of a fellow citizen so Japanese in life and work, concludes the piece by declaring that Miller "is American in spirit and stated that nothing has ever inspired her more deeply than the Washington Monument. 'It is my ambition,' she said, 'to someday make a Japanese wood-block print of the Monument, painting its gray shaft against the red background of a brilliant sunset.'"[33]

Another exhibition, with demonstrations, took place at Philadelphia's Print Club between December 18 - 23. Prints from this and the Washington show reportedly sold to such luminaries as Mrs. Herbert Hoover, Mrs. Gilbert Grosvenor, and Mrs. John Hays Hammond. Miller also had her *Makaen Monastery, Diamond Mountains, Korea* shown at the Art Institute of Chicago's "First International Exhibition of Lithography and Wood Engraving" from December 5 to January 26, 1930. Miller's print was valued at $25, above the $10 to $20 range of most prints but slightly below the $30 for Yoshida Hiroshi's large, spectacular *Snow at Nakazato*. (At a second exhibition in 1932, prints by *shin-hanga* artists Kawase Hasui, Natori Shunsen and Itô Shinsui sold for $3, $4 and $8 respectively.) In January 1930 Miller spoke at the Syracuse Junior League (7th), Rochester's Memorial Art Gallery (9th), and Mark-Murray Galleries, Providence (29th). Kennedy & Co. Gallery in New York City held an exhibition from February 10 - 22 at which Abby Aldrich Rockefeller bought 30 prints. Miller also demonstrated color block printing for The Japan Society in New York, showing prints to Louis Ledoux of the Metropolitan Museum, J. D. Rockefeller Jr. and Madame Debuchi. She then hosted an exhibition from March 6 - 15 at the Art Institute of Chicago, where print curator Helen Gunsaulus took her to see the Gookin, Chandler and Buckingham collections of ukiyoe prints. On March 16 Miller was at the Art Institute of Kansas City and, on March 20, at the Denver Art Museum.

## MICKIE AND NICKIE

ALTHOUGH HER EXPERIENCES in the eastern states generated commercial success for years to come, the highlight of Miller's trip—and that part which reveals most clearly the role of women in promoting and selling her art—came with her first visit to Southern California. In a letter to her parents from the Grand Canyon, Miller details meeting playwright, and Vassar graduate, Mary T. Hamlin—from whom she got the name of dramatic publisher Samuel French for her play *Charan*. Arriving in Pasadena on March 27 for an exhibition and demonstration at the Grace Nicholson

Gallery on Los Robles Avenue, Miller was overwhelmed with the beauty of Southern California and the hospitality of Nicholson, whom she had met in Seoul just eight months earlier. Miller wrote to her parents that she had not expected to like the warm winter of the west:

> But I came down overnight into full springtide and it is simply beautiful here. All the fruit trees are still in blossom, everything is marvelously green, and I simply cannot get over the fragrance of all the orange groves in full bloom. It is absolutely unbelievable. Miss Nicholson took me out motoring the first evening and it was like cutting through great intangible seas of perfume! And her place is the loveliest ever. It is really beautifully done, built around a garden court, green tiles, marble Chinese stairways like those out at the Summer Palace, jaunty eaves, a peach tree in full crimson bloom, birds singing everywhere, and perfectly lovely things in all her galleries. Upstairs she has her own apartment, an extra apartment, which she has turned over to me, and other galleries.[34]

Miller's enthusiasm extended to Nicholson who took her young companion to meet friends for dinner at the Woman's Athletic Club, "the swankiest woman's club in Los Angeles," the Japanese Consulate for an official reception, and then a party hosted by Mrs. Prentiss, daughter of the Severances of Seoul, who were later major Asian art collectors in Cleveland.

Miller's purpose for her Pasadena trip was the print exhibition and demonstrations—the first, on April 1, attended by over 100 guests. *The Pasadena Post* announced the talk in an article on March 21, then reported it on April 2. In the later article the reporter remarks that Miller was "a breath of the Orient in her Japanese costume."[35] A photo of April 1930 (figure 14) demonstrates how Miller not only displayed her prints and the painting which first won her fame in Japan, but also presented herself as an American Japanese. A *Pasadena Star-News* article of April 2 explains that the show attracted much attention because it followed a display of prints by "Yoshido" (presumably Yoshida Hiroshi) and that Nicholson hung "other interesting oriental things"—Ming paintings, Buddhist objects, Japanese old masters, Tibetan banners, and Korean and Mongolian art—in other rooms.[36]

The response generated by these exhibitions reverberated for several years. For example, before sailing home, Miller made plans with the Post Street Bookshop in San Francisco to sell *Grass Blades*, and arranged with Mr. Mackey and Albert Bearden of the San Francisco Art Association to hold an exhibition and

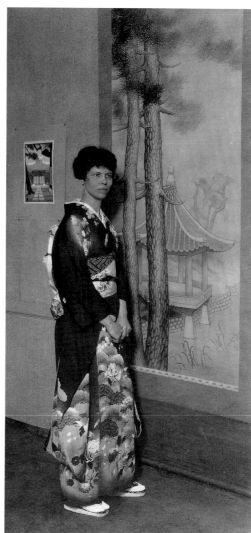

**Figure 14**
Lilian Miller at the Grace Nicholson Gallery, April 1930.
CATALOG 6

28

kimono-clad demonstration. Then, aboard the "President Lincoln" from San Francisco to Honolulu, she met Mr. and Mrs. Hilscher of the Dollar Line who suggested she work as the firm's artist.[37] During a several-week stop in Honolulu, Miller had an exhibition and gave a demonstration for which she was paid $60—an experience which led her to write her parents that she would no longer give free demonstrations but charge $100 on her next tour.[38] That first solo exhibition led to another at the Honolulu Academy of Art in April 1932. Similarly, Elizabeth Whitmore had a second Miller woodblock exhibit at The Print Corner from August 18 to September 17, 1930. And, in April of 1931, Miller's prints were exhibited at San Francisco's Galerie Beaux Arts. The *San Francisco Chronicle* reported: "At first glance Miss Miller's dainty wood blocks would be supposed to be the work of a Japanese artist, although closer scrutiny reveals the Occidental eye and hand."[39] Upon her June 23 arrival in Yokohama on the "President Madison," the Tokyo foreign press played up Miller's success in America to the benefit of her domestic reputation.[40]

While Elizabeth Whitmore was Miller's primary dealer on the east coast, Grace Nicholson filled that role on the west coast. The relationship between the two women transcended the merely commercial connection between dealer and artist and thus reveals the often strong connection between women whose professional and personal lives were not directed by, or toward, men. The Grace Nicholson Collection at the Huntington Library contains nine correspondences from Miller to Nicholson, begin-

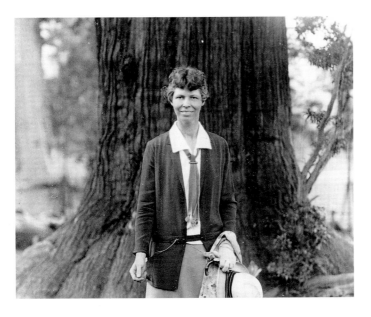

ning with an undated note written during Miller's stay with Nicholson and concluding with a 1935 Christmas card. Although Nicholson's letters to Miller have not been found, they seem to have been far more numerous as a constant theme in Miller's replies is the plea for forgiveness at the tardiness, scarcity and paltriness of her responses in contrast to Nicholson's frequent and fulsome letters, cables, and gift packages (of hankies and underwear). Although some early letters use the names "Grace" and "Jack," the intimate bond between the women is reflected in their pet names "Nickie" for Nicholson and "Mickie" for Miller. These nicknames were in fact first lent to a pair of turtles given by Miller to Nicholson in Pasadena.

The letters imply tension between

**Figure 15**
Lilian Miller by tree in Nara, May 1931.
CATALOG 7

Miller's promise to return to Pasadena and her desire to remain at home in Japan. The short note of April 30, 1930 tells how Miller received word from her father that his temporary recall to Washington from Seoul would be permanent; she signs off with an enthusiastic but ambiguous suggestion of future possibilities with Nickie: "So . . . ???!!! Micky." In the next letter of May 22, she admits:

> *I am so happy, too, to be aboard ship again and heading for Orient seas.*
> *The minute the steamer passed out through the Golden Gate I knew I had*
> *done the right thing for us to return eastwards again. . . . I do hope all is*
> *peaceful and serene with you. Thank you again for the lovely, lovely time*
> *you gave me in Pasadena. Surely we will have many more such in times*
> *and days to come. I have such a happy feeling with something definite in*
> *the future to come back to.*

In a February 11, 1931 letter to "Grace-Nickie—you old peach," sent from the Miyako Hotel in Kyoto, Miller confesses her unhappiness when first back in Japan as well as her decision to give Kyoto one more try. In an August 25, 1931 letter to "Dear Old 'Nickie,'" sent from the Kanaya Hotel in Nikkô and including a photo of herself in Nara (figure 15), Miller writes that next year she will "wend my trail your way. And I have every hope of coming to see you—if you'll still have me by that time!—on my way east to Washington." She also speaks of desiring to paint Pasadena estate gardens to earn money. While the next letters of December 1, 1931 and February 27, 1932 make no mention of return, in a June 3, 1932 letter from Kyoto, Miller recalls "that wonderful April" of 1930 but explains that she must "stay put" in Japan because of the Depression in America and the fact that she can live well on the dollar in Japan. The last note, a Christmas card in 1935, offers only "All my love, dear Nick, if you'll forgive your erring friend," and a sample of her latest prints.

## TRANSCENDING THE BOUNDS OF EAST AND WEST

WOVEN AROUND MILLER'S promises to return—and excuses for not doing so—are updates on the aesthetic and commercial aspects of her career. In the missive of February 11, 1931, Miller explains how she has been enchanted by Kyoto and must stay for a while to make sketches and paintings because her print-making tools are still in Seoul. She also recounts how she has staged several small exhibitions of her prints at the hotel in Kamakura where she spent the summer, and thus sold prints "to people passing through and to the wealthy and cultured Japanese. . . ." She then inquires if Nicholson has recently sold any of her prints. By August 25 of that year Miller explains how she is "slowly evolving a new style of watercolor—part Japanese and part <u>me</u>— something I've never tried before." She admits that these pretty scenes of Japanese gardens sell well. A year later she confesses that financial worries brought on by the death of her father on April 26, 1932, and the new responsibility of taking care of her mother on a paltry life insurance settlement and government pension, means that she must continue to make watercolors "in my new Japanese style" because "almost as fast as I paint them I sell them." The Miyako Hotel also commissioned her to produce the five-foot long watercolor *Springtime Over Kyoto*.

This furious production resulted in an exhibition of 85 watercolors at the Shiseidô Gallery in Tokyo's fashionable Ginza district (figure 16), held December 13 - 17, 1933.[41] The small gallery did not allow for hanging prints, but they were presented in a portfolio by the entrance desk. Esther Crane's articles in *The Japan Advertiser* of December 10 and December 15 disclose that the paintings were of traditional Japanese scenes, mostly from Kyoto and Nikkô (see Appendix for titles). The paintings, made with a flat Japanese brush, were primarily rendered in watercolor and Japanese pigments on Japanese paper, although several were ink monochrome. Crane attributes Miller's success to her bi-culturalism:

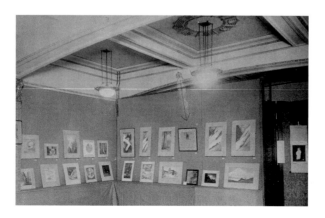

**Figure 16**
Shiseidô Gallery exhibition, Tokyo, November 1933.
CATALOG 8

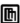

*The keynote of Miss Miller's art, indeed, is that she has had the
intelligence and imagination to adapt her knowledge of Japanese painting
to western tastes and ideas, so that she has evolved a style of her own
which is fresh, festive and individual. In achieving this happy medium
of interpreting Japanese subjects in such a fashion as to give them value
and meaning to the western eye, Miss Miller's work is the admirable
product of an American girl brought up in Japan which has distinct
appeal to people of both nationalities.*[42]

Given this stylistic transnationalism, it is not surprising that the show was sponsored by a group of powerful Japanese and American "patronesses" at the heart of the Tokyo diplomatic corps: Viscountess Saitô, wife of Japan's Prime Minister; Mrs. Joseph Grew, wife of the American Ambassador; Countess Uchida, wife of the former Minister of Foreign Affairs; Mrs. Yoshida, wife of the former Japanese Ambassador to Italy; Mrs. E. L. Neville, wife of the American Counsellor; Marchioness Tokugawa Yorisada; Mrs. Arthur William Carey Crane, wife of the American Military Attaché; Mrs. Arthur Garrels, wife of the American Consul-General; Mrs. Fukui Kikusaburô, Mrs. Kadono; Mrs. Charles de Vault of the American Consulate in Yokohama; and Mrs. B. W. Fleisher. Mrs. Grew, who gave a tea at the embassy in honor of the patronesses and the artist, also purchased many of Miller's paintings to hang in various embassy rooms.

Internationalism marked Miller's life and art in the early 1930s. As a respected member of the American expatriate community with a native knowledge of Japan, Miller was chosen by Ambassador Grew to lead himself and visiting dignitaries Charles Lindbergh and Ann Morrow Lindbergh around Nikkô on October 27, 1931.[43] Her work was also collected by Mrs.

**Figure 17**
*Mountain Path
and Azaleas,
Nikko,* 1935,
watercolor
on paper.
CATALOG 27

Lindbergh when she resided briefly at Karuizawa. Miller also established a friendship with the novelist L. (Lily) Adams Beck, famous for her 1930 study of Oriental culture *The Way of Power.* Miller met Beck, and her young Canadian secretary/companion, in the summer of 1930 at a hotel in Kamakura and continued the merry friendship until the older woman suddenly died after one particularly festive evening.[44] Miller's letters to Nicholson also disclose that in the spring of 1931 her residence at the Miyako Hotel led to meeting the avant-garde Japanese dancer Itô Michio as well as a brief friendship with Isamu Noguchi, "another artistic confrere," as they toured Kyoto temples. The two

artists, along with the Japanese oil painter Fujita Tsuguji (aka Léonard Foujita), were linked in the article "Three Artists Who Transcend The Bounds of East and West," in the February 1931 issue of *Asia*. Fujita represented a Japanese successful in Europe, Miller the American trained in Japan, and Noguchi the artist with genes, schooling and a style representing both countries.[45] Miller was featured again in *Asia* in 1934 when Harold Henderson, a haiku poet and Zen student resident in Japan, wrote an article on her as an artist combining the traditions of the Orient and Occident: "Because of her understanding of the Japanese spirit she has been called one of the three best unofficial ambassadors between America and Japan, the other two being Japanese."[46]

Miller's energy as well as her diverse talents largely account for her broad range of

contacts. In 1931 alone she was elected to the League of American Pen Women, continued to collaborate with Joan Grigsby, and was selected by the Japanese government as the only non-Japanese on a committee charged with choosing works for an exhibition of Japanese paintings to be sent to the Toledo Art Museum in Ohio. In addition to making well over 100 watercolors—*Mountain Path and Azaleas, Nikko* (figure 17) is a representative example—Miller created nearly 20 new woodblock prints in the early 1930s. Continuing to produce her prints, and typically using about 20 printings for each proof (by her own account), this devotion to craftsmanship exacted a physical toll. Nonetheless Miller remained vigorous, spending her summers in Nikkô. In a December 1, 1931 letter to Nicholson, Miller writes that despite suffering from her "old nemesis" lacquer poisoning:

> *I had a glorious time in Nikko and I adore every stone, wall, walk, tree, and grass blade in that place. Not to mention the mountains. Those mountains are all my friends now. I spent every day I could on the main range soaring to the sky. I did 4000, 5000, 6000, 7000, 7500 feet nearly every other day. For the first time in nine years I got back to my old form and felt as strong and athletic as I did before all my beastly long illness. It did seem so wonderful once more to be <u>Jack Miller</u> again (I've been for so long only a weak, puny, sickly replica)!*

Miller's physical energy was matched by the strength of her political convictions. A letter to Nicholson from early 1932, as Japan was being criticized internationally for its interference in Manchuria and China, finds Miller "aghast" at the American public's "naive" support for China and condemnation of Japan: "I think Stimson must be plumb crazy. He's so pro-Chinese he can't see straight." After attacking Chinese corruption she writes: "And here's Japan doing the dirty work and using the only kind of argument our Chinese warlord friends can understand—and the whole U.S. is calling Japanese militaristic and moaning over the Chinese being killed. . . . Ye gods! Aren't Americans capable of making themselves the <u>damndest</u> fools! The thing that worries me is that after all these years we are deliberately throwing away Japanese respect and friendship. It seems cruelly hard." Miller ends the diatribe by criticizing the hypocrisy by which Americans sent Pershing to Mexico and rigged Nicaraguan elections yet maintain "lovely, floating angel-feather ideals."

## FRAGILE MORNING MISTS

MILLER'S VIGOROUS HEALTH and political support of Japan changed dramatically in 1935 and 1936. In 1935 she was diagnosed with a large cancerous tumor and had her uterus and ovaries removed. Then, in early 1936, after Japanese radical officers assassinated several leading politicians in a coup attempt, Miller and her mother moved from Japan to Honolulu—that part of America geographically and culturally closest to Japan. In the temperate climate of Hawai'i, Miller never unpacked her printing tools but instead devoted herself to watercolors as well as painting in *sumi* (ink) on scrolls, screens and even walls. The boldly experimental *Landscape with Waterfall* (figure 18) of 1937 demonstrates the freedom in technique wrought by Miller's fresh surroundings. She usually worked outdoors (figure 19) and "became interested in mountain landscape and spent months in studying and photographing cloud effects and mountain structure—adapting herself to the atmosphere of the Islands—before putting brush to paper."[47] Miller also cultivated powerful female patrons, placing her new paintings and some older prints with such leaders in Honolulu society as Louise Dillingham, founder of the League of Women Voters in Hawaii and member of the "Friends of the Academy," and Alice Cooke Spalding, daughter of Anna Rice Cooke—

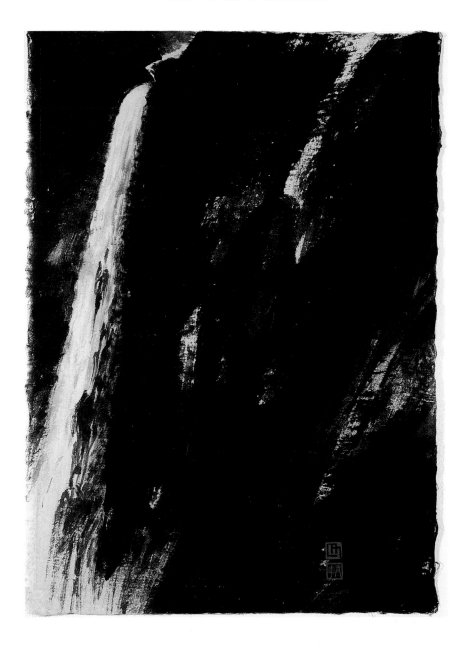

**Figure 18**
*Landscape with Waterfall*, 1937, ink on paper.
CATALOG 28

**Figure 19**
Lilian Miller sketching in Hawai'i, ca. 1936.
CATALOG 9

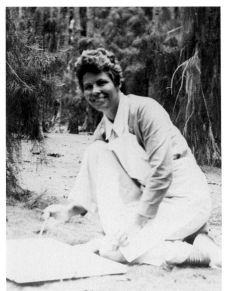

matriarch of the Honolulu art world who founded the Honolulu Academy of Arts and organized its 1932 Miller exhibition.

Cooke had installed Catherine Bean Cox as the Academy's first Director in 1924 and it was in this supportive female environment that Miller had a "brush painting" exhibition from March 2 - 14, 1937, then gave a demonstration of her technique in late December 1937. On September 8, 1938 Miller lectured on "How To Make A Woodblock Print," and worked with printing technicians at the *Honolulu Star-Bulletin* to produce the lithotint *Spray of Bamboo* (figure 20) for the 10th annual exhibition of the Honolulu Print Makers at the Academy. Miller gave the institution her lithograph *Bamboo* in May 1938 and *Pines of the Heights* (figure 21) in August, the same month that she sold them 43 Japanese woodblock prints and four stencil prints. In November she gave the Academy several of her own prints. Although Miller and her mother left Honolulu late in 1938, in June 1940 the museum exhibited her prints along with those of Charles Bartlett,

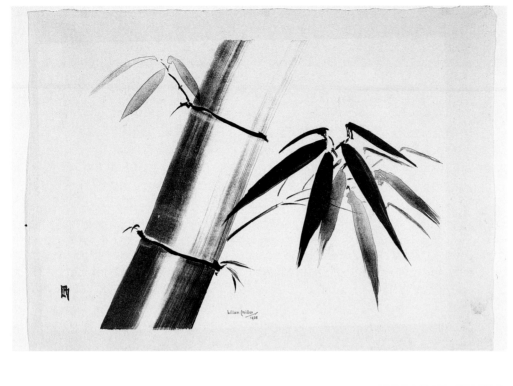

**Figure 20**
*Spray of Bamboo*,
1938, lithotint.
CATALOG 112

Pieter Irwin Brown and Elizabeth Keith. In spring 1943 the Academy held a Miller memorial show, using works in the museum and from local collectors. Miller's maturation in Hawai'i is reflected in a Christmas portrait of 1938 (figure 22), subsequently used in her brochure.

The reasons for Miller's relocation to San Francisco are unclear but access to larger commercial markets may well have been key. Mother and daughter inhabited a room in the El Drisco Hotel on Pacific Avenue near Davisadero Street. Miller sold prints and new paintings at Gump's, San Francisco's premier Asian art gallery. Miller had long admired the massive cryptomeria and cedars familiar from her summers in Nikkô; but in California she became nearly obsessed with the massive redwoods, capturing them in photographs and ink paintings (figure 23). The *San Francisco Chronicle* critic Alfred Frankenstein reviewed her mid-November 1939 Gump's exhibition of ink paintings, praising the "dark and overcast moods" of Miller's Monterey cypresses (figure 24) and California redwoods: "her big studies of the huge columns of the redwoods catch the grand monumental size of those botanical miracles with unusual conviction."[48] In her own brochure Miller writes: "Whether poetic or dramatic, her sureness of brush-stroke catches the bold sweep of mountain and plain, the fragile morning mist just dispersing from valleys, the stalwart majesty of Japanese redwoods." In these botanic cousins, the Pacific Coast redwood and Japanese cryptomeria, Miller found a potent symbol linking Japan and California.

Miller also continued to promote herself with demonstrations: her large brochure "Lilian Miller, Artist, Lecturer, Woodblock Printer" touts "actual platform demonstrations" and the small brochure "Lilian Miller (Famous Artist in Oriental Brushwork)" advertises lectures in Oriental painting ("with Oriental brushes") and in Oriental

**34**

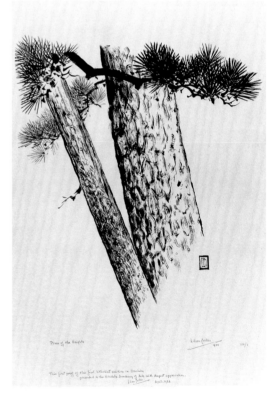

**Figure 21**
*Pines of the Heights*,
1938, lithotint.
CATALOG 109

Woodblock Prints (with "blocks cut and printed before audience"). Grace Nicholson visited Miller during a trip to the 1939 Golden Gate International Exposition and they planned an exhibition in Pasadena for the following year. On March 20, 1940 Miller gave an "Oriental Brushwork Demonstration" at the Nicholson Gallery. The *Pasadena Post* article "American Woman Becomes Renowned Oriental Artist," with the photo caption "Painter Beats Japanese At Their Own Art," recounts Miller's usual list of accomplishments with a somewhat jingoistic air. Miller's charisma appears stronger than ever in that the female reporter begins the article by describing the forty-five year-old artist's "Amelia Earhart boyishness," cropped iron hair, and "soft lichen green [clothes] against her olive skin."[49]

By this time Miller's relationship with Nicholson seems to have become largely professional as the artist was developing new friendships. One such friend was Lucile Phillips Morrison—a wealthy Vassar graduate of 1917, mother of four sons and an adopted daughter, author of such romantic novels as *Doll Dreams* and *Lost Queen of Egypt,* patron of female writers and artists, and trustee of Scripps College. Miller not only hand-illustrated a copy of *Grass Blades From A Cinnamon Garden* (figure 25) for Morrison, but sent her a number of illustrated poems with often romantically effusive content.[50] In the summer of 1941 Miller and another friend, Adele Buckner, wife of the head of the Alaska Defense Command, "vagabonded" by foot, ship and train for three weeks in southwest Alaska. While Buckner captured the experience in words for *Alaska Life,* Miller photographed, sketched and painted.[51] Again the old "Jack Miller" returned. And again her joy in making art and friends was cut short by war and illness— the scourges of 1935 and 1936 now reappearing in far more virulent forms.

**Figure 22**
Lilian Miller,
Christmas, 1938.
CATALOG 10

**Figure 23**
*Redwoods,* 1939,
ink and color
on paper.
CATALOG 31

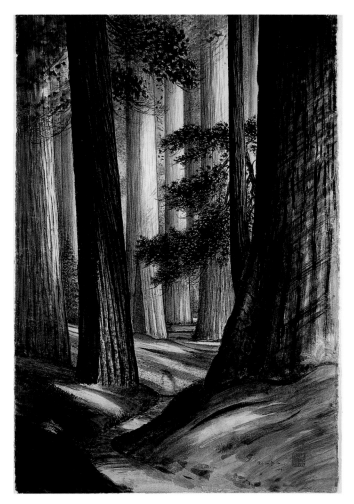

35

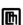

**Figure 25**
Hand painted
dedication page of
*Grass Blades from a
Cinnamon Garden*,
1940, ink and
color on paper.
CATALOG 38

**Figure 24**
Lilian Miller in
front of a painting,
ca. 1940.
CATALOG 11

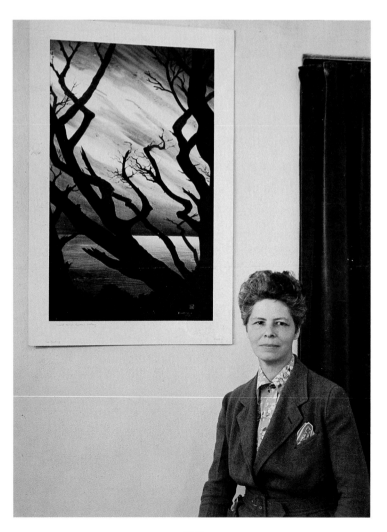

## WAR WITHOUT MERCY

BY THE TIME ADELE BUCKNER's vibrant article on her Alaskan lark with "Jack" Miller was published, Japan had attacked Pearl Harbor. Miller's reaction to "Black Sunday" was of bitterness and betrayal after her own life in Japan and her father's career built upon helping Japan achieve "an honorable place among nations." In a letter published in the "25th Reunion Booklet" for the Vassar Class of 1917, Miller writes: ". . . as the unbelievable reports came over the radio, one clear fact immediately stood out for me: —namely, that from that moment I must put away my brushes 'for the duration' and find some way in which my knowledge of Japan and of Japanese, could be of service to our country."[52] She signed up with a propaganda and counter-propaganda branch of the Navy to fight the "War of the Air Waves" in which radio messages were beamed around the world to comfort American troops and allies as well as to afflict the enemy. Miller was made "Research Analyst and Japanese Censor" and, with her "knowledge of Japanese psychology" and language, was placed in charge of gathering information to broadcast. She also checked that the translations made by Japanese Americans did not contain any "unauthorized information." The broadcast schedule meant work from two pm until well after midnight. However, Miller ends her letter by stating that in the epic struggle it gives great satisfaction to "break down Japanese morale." Elizabeth Whitmore, in a dramatic 1953 postscript to her biographical sketch of Miller, adds that early in 1941 Miller sent her a large group of prints for exhibition at the Currier Gallery of Art in Hanover, New Hampshire. After Pearl Harbor, however, Miller requested that all her work be destroyed. Upon Whitmore's pleading that "ART is NOT a national matter" and that the artist is "after all, not a born Japanese," Miller relented by withdrawing only the early "charming" prints and offering the others at lowered prices.

Whitmore concludes that Miller literally worked herself to death, "an innocent sacrifice to the war spirit, as truly as if she had been bombed in Japan." But, in truth, during her propaganda war against Japan, Miller was fighting an even more tenacious enemy. In October 1942 Miller was stricken with jaundice and Adele Buckner placed her in the care of Dr. Ann P. Purdy. On December 9 an operation at Stanford University Hospital revealed a large malignant tumor in Miller's abdomen and the fact that she had little time left to live. Ambassador Joseph Grew, in a March 12, 1943 condolence letter to Harriet Miller Cooper, writes that he visited "Jack" in the hospital and that she was "brave and lovely as always. . . ." Lilian "Jack" Miller died on January 11, 1943 at age 47.

The *San Francisco Chronicle* carried the news of Miller's death in a two-line obituary provided by the mortuary. A month later the *Honolulu News-Bulletin* ran a somewhat longer story. The family originally planned to send Lilian's ashes along with those of her mother to the cemetery in Yokohama where the two women had interred Ransford Miller in 1932. However, Lily Miller's near destitution—Lilian's estate, $575.11 in cash and $1065.36 in "stock" (her art) on hand, netted only about $800 dollars after hospital expenses—meant that Lilian's ashes were interred at Woodlawn Cemetery in San Francisco. Her friends Clarascott Bruce and Adele Buckner settled the estate, giving some prints to the Honolulu Academy of Arts and the bulk of the prints, books, tools, materials and the famous *In A Korean Palace Garden* to Scripps College where Lucile Morrison was a trustee and where, before her death, Miller had hoped to find a teaching position. By 1951, with Japanese culture near its nadir of popularity in the America and with the artist no longer around to give demonstrations (and garner press coverage), Whitmore offered many of Miller's prints at about half the price she had asked in 1941.

It was indeed "sometimes difficult to be a messenger between east and west." In the decades after World War II, poetic evocations of Korea and Japan were well out of

fashion, and so too was Miller. Even when scholars began to study prints of the 1920s and 1930s, because Miller fit neatly into neither the circle of Western artists who worked in Japan nor the group of Japanese *shin-hanga* artists published by Watanabe, they over-looked this artist who resides so resolutely between two cultures of production, national affiliation and identity. Miller's status as an unmarried and autonomous woman, a "woman-identified woman," placed her even farther outside the mainstream as constructed by normative art history. While Miller's complex national, cultural, commercial and sexual affiliations do not "explain" her art or her life, Miller's attempts to mediate simple categorization suggest some of the critical contexts in which her life and work can be profitably analyzed. When the lens of scholarly inquiry is widened to take in the edges as well as the center, Lilian Miller begins to come into focus. As we start to understand Miller, some of our basic assumptions about the role of women artists in Orientalist discourse become that much more complex.

**Detail**
*Black Bamboo*

## NOTES

1. Lilian Miller, "An American Girl And The Japanese Print," *Vassar Quarterly* (May 1932) p. 123.

2. Homi Bhabha, *The Location of Culture* (London: Routledge, 1993) p. 1.

3. Miller can surely be plotted somewhere on Adrienne Rich's much critiqued but highly influential "lesbian continuum" ranging from lesbian sexuality to "woman-identified experience," defined in part as "forms of primary intensity between and among women, including the sharing of a rich inner life, the bonding against male tyranny, the giving and receiving of practical and political support." For this "feminism of action," if not always of theory, see Adrienne Rich, "Compulsory Heterosexuality and Lesbian Existence," in Ann Snitow, ed. *Powers of Desire* (New York: Monthly Review Press, 1983) pp. 177-205.

4. "Lilian Miller, Artist, Lecturer, Woodblock Printer," (privately published pamphlet, ca. 1940) p. 2.

5. Among print designers active in Japan, Helen Hyde, Bertha Lum and Elizabeth Keith all first traveled to Japan as adult women. Similarly, Friedrich "Fritz" Capelari, Charles Bartlett, Cyrus LeRoy Baldridge, and Pieter Irwin Brown all journeyed East as grown men. Only Paul Jacoulet, born in France, was raised in Japan and spent virtually his entire life there. For his biography, see Richard Miles, *The Prints of Paul Jacoulet* (Pasadena: Pacific Asia Museum, 1982); for those of other Western print-makers in Japan, see Helen Merritt, *Point of Contact: Western Artists, Japanese Artisans* (DeKalb, IL: Northern Illinois University Art Museum, 1993), Yokohama Art Museum, *Eyes Toward Asia: Ukiyoe Artists from Abroad* (Yokohama: Yokohama Art Museum, 1996), and Julia Meech, "Japonisme: graphic arts in the early twentieth century" in Amy Reigle Stephens, ed., *The New Wave, Twentieth-century Japanese Prints from the Robert O. Muller Collection* (London and Leiden: Bamboo Publishing and Hotei Japanese Prints, 1993). Miller appears only in the Yokohama catalog, and then with but a sketchy biography.

6. Lilian Miller lists these hobbies in her entry in the 1942-43 *Who's Who In California, vol. I*. Elizabeth Whitmore's unpublished short biographical sketch, "Lillian [sic] May Miller Painter and Maker of Block Prints," written in 1933 and appended in 1951, claims that Ransford's "discriminating intelligence and sterling honesty of mind can be traced in the daughter's character, both as inheritance and as a consciously chosen model." Ransford Miller's devotion to Japan and his respect there are best demonstrated by the fact that after his death in Washington DC on April 26, 1932, his ashes were sent to Japan for interment in Yokohama, with Premier Saitô himself attending the August 25 memorial.

7. William Franklin Sands, *Undiplomatic Memories, The Far East 1896-1904* (New York: Whittlesey House, 1930) p. 22.

8. Harriet Miller Cooper, "Japanese Woodblock Prints of Lilian Miller," January 7, 1930 letter to Miss Olmstead of the Syracuse Museum of Fine Arts. Special Collections, Vassar College.

9. Inside the front cover of the book is a sheet of paper on which is written: *gô, Gyokka, Meiji yonjûnen, sangatsu, Bokusen sen* [artist's name: Jeweled Flower, 1909 March, selected by Bokusen].

10. Whitmore, "Lillian [sic] May Miller, Painter and Maker of Block Prints," p. 1.

11. Gretchen Smith, "American Girl, Born in Japan Gains Fame in Eastern Art," *The Evening Star*, (Washington DC) November 21, 1929.

12. Steward J. Teaze and James D. Tobin, "Modern Japanese Wood-block Prints Shin-Hanga, Traditional Print Makers," undated and unpublished manuscript, Special Collections, Northern Illinois University.

13. Rackham's illustrations appear in the 1908 edition published by W. Heinemann, London and in the 1977 reprint of that edition by The Viking Press, New York.

14. William Drake, *The First Wave, Women Poets in America 1915-1945* (New York: Macmillan, 1987) p. 240. Drake postulates that although women realized that "supportive relationships" in a "nexus of loving personal relationships" were crucial to the expression of female creativity, they had neither a conceptual understanding of this need nor the language to acknowledge it.

15. Harriet Miller, "Japanese Woodblock Prints of Lilian Miller," p. 2.

16. Smith, "American Girl, Born in Japan Gains Fame in Eastern Art," *The Evening Star*, November 21, 1929.

17. Harriet Miller, letter of July 25, 1921 to James Cooper, from Nikkô, Japan.

18. This story is given in the biographical sketches by Whitmore and Teaze as well as in Harold G. Henderson, "Japanese Prints By An American," *Asia* XXXIV:9 (November 1934) p. 562.

19. John Stewart Happer, "Art and Crafts, Modern Wood Engraving and Colour Prints," *The Far East* 22:5 (May 28, 1921), pp. 164-68.

20. "American Girl Depicts Spirit of East Through Color Prints," *The Japan Advertiser*, January 28, 1922, p.2.

21. Nadia Lavrova, "Vassar Girl Portrays Hidden Beauty of Korea In Color," *The San Francisco Examiner*, August 12, 1923, p. 3.

22. Harriet Miller, letter of July 25, 1921.

23. Joan S. Grigsby, *Lanterns By The Lake* (London: Kegan Paul, Trench, Trubner & Co., Kobe: J. L. Thompson & Co., 1929), p. 15. In one copy of the book is a letter of October 26, 1930 from Grigsby to a Mr. Rabbett, which includes the sentence: "Jack and I had a glorious time in Kyoto. The days went all too quickly." Miller also illustrated Grigby's *The Orchid Door, Ancient Korean Poems,* first published in 1935.

24. Grigsby, *Lanterns By The Lake*, pp. 134-35.

25. Lilian May Miller, *Grass Blades From A Cinnamon Garden* (Tokyo: The Japan Advertiser Press, 1927) p.14.

26. ibid., p. 29.

27. ibid., p. 84.

28. Grace Nicholson Orient trip diary, Grace Nicholson Collection, Huntington Library.

29. An undated and unidentified Japanese newspaper article in the Huntington Library reveals that Griffiths intended to open an Oriental art shop in Phoenix, Arizona. The friends spent the night before sailing with Lieutenant and Mrs. Carl E. Englehart in Omori.

30. Smith, "American Girl, Born in Japan Gains Fame in Eastern Art," *The Evening Star*, November 21, 1929.

31. "This Japanese Artist Is An American," *Art Digest* (Mid-October, 1929) p. 22.

32. "Life in Japan and Korea. Wood-Block Prints in Colour by Lilian Miller," pamphlet by Gordon Dunthorn, Washington DC, 1929.

33. Smith, "American Girl, Born in Japan Gains Fame in Eastern Art," *The Evening Star*, November 21, 1929. Although Miller never made a print of the Washington Monument, *shin-hanga* artist Kawase Hasui produced one in 1935.

34. Lilian Miller, letter of March 28, 1930 to her parents, from Pasadena.

35. In "Oriental Prints To Be Described," *The Pasadena Post*, March 21, 1930, p. 1, Nicholson discloses that Miller's tour is a response to the request of many friends to see her "exquisite prints." See also *The Pasadena Post*, April 2, 1930, p. 2.

36. "Lilian Miller Block Prints Exhibited," *Pasadena Star News*, April 2, 1930, p. 3. The sub-headlines read: "Talented Artist Now at Nicholson Gallery," "American Woman Born in Tokyo," and "United States Consul's Daughter Is Genius."

37. Lilian Miller, letter of May 22, 1930 to Grace Nicholson, on board the "President Lincoln" en route from San Francisco to Honolulu. Huntington Library.

38. Lilian Miller, undated letter (ca. early June 1930) to her parents, from Honolulu.

39. "Color Prints of Lilian Miller Shown at Beaux Arts," *San Francisco Chronicle*, April 12, 1931, p. 10.

40. For instance, Miller's return to Japan and success in the U. S. were reported in "Miss Miller Back From U. S. Lectures," *The Japan Advertiser*, June 24, 1930, p. 1. She is listed with Bertha Lum and Elizabeth Keith, but is implicitly ranked above them.

41. "Water Colors and Woodblock Prints by Lilian Miller," Shiseidô Gallery pamphlet, Tokyo, 1933.

42. Esther Crane, "Tokyo Society Notes," *The Japanese Advertiser*, December 10, 1933, p. 10. The second article is "Miss Miller's Art is Shown At Best," *The Japanese Advertiser*, December 15, 1933, p. 2.

43. Joseph Grew, *Ten Years In Japan* (New York: Simon and Schuster, 1944) p. 54

44. The friendship with Beck is recounted in Miller's February 11, 1931 letter to Nicholson, signed "your erring and penitent, Mickie."

45. "Three Artists Who Transcend The Bounds of East and West," *Asia* XXXVI:2 (February 1932) pp. 114-16.

46. Harold Gould Henderson, "Japanese Prints By An American," *Asia* XXXIV:9 (November 1934) pp. 562-63.

47. "Lilian Miller," *Honolulu Academy of Arts News Bulletin and Calendar,* V:2 (February 1943) p. 6.

48. Alfred Frankenstein, "Around The Art Galleries," *San Francisco Chronicle,* November 12, 1939, p. 36. A photo of an ink painting of cypress is featured in the same column in the *Chronicle,* November 19, 1939, p. 22.

49. Ruth Billheimer, "American Woman Becomes Renowned Oriental Artist, Lillian [sic] Miller, Who Grew Up In Japan, China, Korea, Comes Here To Paint California In Technique She Learned In Asia," *The Pasadena Post,* April 7, 1940, pp. 1, 17. Miller's ink paintings of Chinese poems, made for a Chinese language class in Los Angeles, are reported in "Chinese Poem Is Translated, Illustrated," *Pasadena Star-News,* May 1, 1940. Miller may well have identified with the famous aviatrix Earhart: her nephew Ransford Cooper reports receiving a book on Earhart from "auntie Jack" for his birthday in 1939.

50. One poem concludes: "And thus you too/ Come like a sudden radiance in its might/ Sweeping my heart! I stood and turned to you/ Unutterably drawn . . . with light above,/Light everywhere . . . proud with new joy . . . your love . . ." Another poem, "Blue," ends: "And yet the loveliest blue in many a year/Has come to me in eyes that dance. . . and dream . . ./And those eyes, yours!"

51. Adele Buckner, "Notes of An Alaska Vagabond," *Alaska Life,* (December 1941) pp. 6, 7, 16.

52. In a document titled "From the 1917 25th Reunion Booklet, Lent to me by Charlotte Babcock Sills." An envelope from the San Francisco District Staff Headquarters of the Navy Department addressed to "Lillian [sic] Miller," postmarked November 14, 1940, shows that Miller was contacted by the Navy prior to the outbreak of war.

**Detail**

*The Little Shrine
On Quiet Hills*

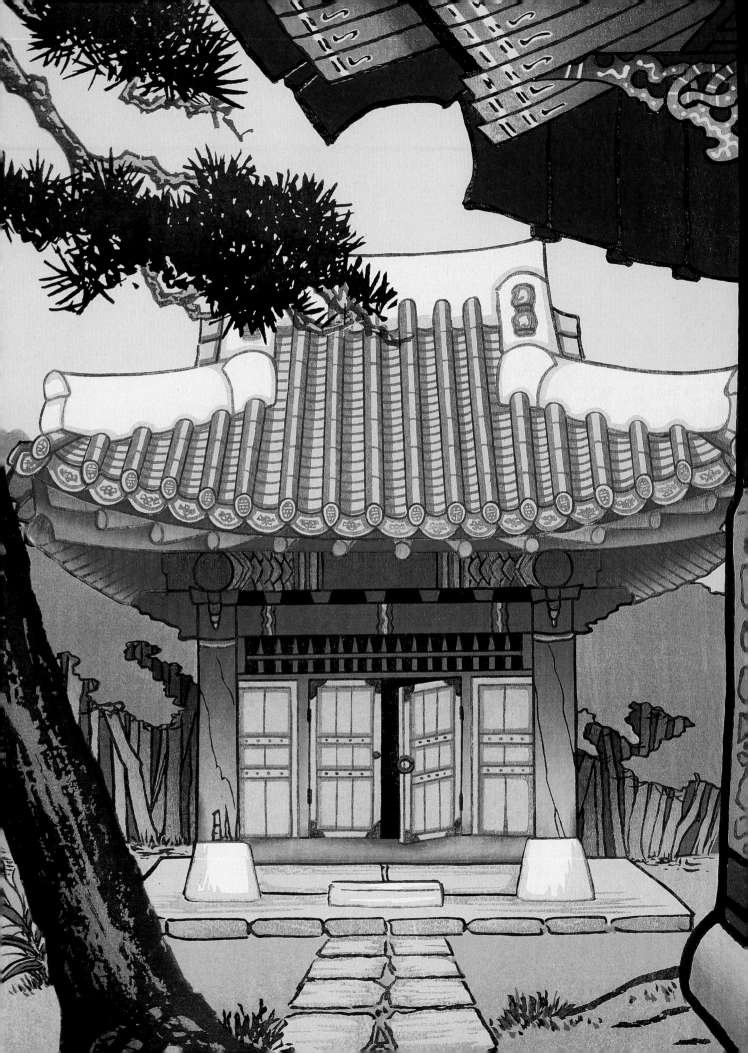

# THE
# AMBIVALENT GAZE:

## *Miller and Orientalism*

### ORIENTALISM, GENDER AND ART

 **OMPARED TO THE LIVES OF MOST PEOPLE,** Lilian Miller's life was less about simply being than it was about translating and negotiating the cultures she lived in and for. Miller's life and art bespeak a carefully brokered status as simultaneously insider and outsider not only in Japan—land of her birth and artistic training—but also in America—country of her citizenship and that of most of her patrons. Perhaps because her own sense of identity was so fluid or indeterminate, Miller often sought to make the subject of her art—the Orient as represented by Japan and Korea—into something static, frozen beyond the grasp of time. Born in Japan in the midst of epochal and fractious change from "traditional" Oriental culture to "modern" Western culture, Miller studied Japanese arts—specifically, the conservative Kano style of brush painting—in the midst of the nation's transformation and inevitable reactionary resistance. Thus, Miller's emphasis on "fixity" in her construction of the Orient is connected in part to the "self-Orientalizing" mode in which many Japanese performed a similar operation on their own culture and on that of their colony Korea. The parallel between Miller's work and such nativist Japanese artistic movements as *shin-hanga* does not explain her art but underscores the dense weave of cultural politics in this period.

Despite the complexity involved in applying the concepts of Orientalism to early twentieth-century Japan and to Lilian Miller, given her primary cultural identification with that country, nonetheless, as an American translating the culture of the Orient to the West, Miller was inextricably bound up in the "Orientalist" discourse through which the West projects its identity and power by systematizing knowledge about, and de facto creation of, the East. This highly politicized set of self-regenerating constraints and expectations essentializes the Orient and drains its humanity by fixing it in an eternal past which is then saved by the Western writer, artist or historian who is thus the Orient's creator and preserver. In this way, the strangeness of the East is made to increase the more the West encroaches upon it. As a corollary, the Orient, though a construct, is made to seem natural so as to confirm the naturalness of Western dominion.[1]

**43**

**Detail**
*A Korean Shrine,*
1928.
CATALOG 71

In the analysis of Linda Nochlin, Orientalist art, as manifest in nineteenth-century European painting of the Middle East (the "Orient" in Edward Said's original analysis of Orientalism), is composed of four "absences" which define it as a type of "picturesque" imagery. In paintings by such artists as Jean-Léon Gérome and Eugène Delacroix, the Orient is a "world without change, a world of timeless, atemporal customs and rituals . . . ." The presence of the West is never acknowledged but always implicitly present in the gaze which controls the objects in the painting. The paintings thus strive to make the viewer believe that they are true "reflections" of "Oriental reality." This goal is achieved through "naturalist" styles which attempt to hide the fact that this art is really just art by claiming it as reportage. At the ideological heart of the Orientalist picturesque is the desire to "mask conflict with the appearance of tranquillity." And it is precisely when the Orient is in the midst of change that its ways of life are deemed worthy of preservation in art—art which transforms the people of the Orient into objects of "esthetic delectation." This status defines the subjects of Orientalism as inalterably different from, and implicitly inferior to, those who construct and consume the images. Central to this process of differentiation is a style based on the "strict avoidance of any hint of conceptual identification or shared viewpoint" with the subject.[2]

For Nochlin, it is by rejecting the signs of Western rationalism through "flatness, decorative simplification and references to 'primitive' art," that artists can avoid the ideological implications of the picturesque. Yet, given that by the beginning of the twentieth century those very stylistic features had become the hallmarks of *Japonisme* in painting, in the context of East Asian Orientalism do they still signal "conceptual identification" with the subject and thus articulate a counter-discourse to Orientalism? Are artists like Lilian Miller, Helen Hyde (1868-1919) and Bertha Lum (1869-1954) who adapt Japanese styles thereby less complicit in Orientalism than Elizabeth Keith (1887-1956) who deploys the naturalistic mode of reportage? Or, does an "Oriental style" imply a deeper level of Occidental hegemony over the Orient? To complicate the issue further, because the enterprise of Western domination over Asia was carried out largely by males, and because in Europe and America women filled an inferior social position, do these facts imply that female artists likely approached the Orient with a sympathy born of a similarly subaltern status? Moreover, if Orientalist ideology is built on the authority of the conventions of Western civilization, do these artists' unconventional social and sexual identities—neither Miller, Hyde nor Keith married, and Lum spent most of her career separated then divorced—further align them against the patriarchal values of Orientalism?

There are no simple answers to these questions. However, Nochlin issues an instructive warning: "It is . . . important to remember that symbolic power is invisible and can be exercised only with the complicity of those who fail to recognize either that they submit to it or that they exercise it. Women artists are often no more immune to the blandishments of ideological discourse than their male counterparts."[3] In her book on several female artists and writers in nineteenth-century France and Britain, Reina Lewis addresses precisely the conditions for the creation and reception of women artists in the context of the cultural production of Orientalism. She posits that imperialism was central to women's creative opportunities, in many cases suggesting subjects and styles, the assessment of their work, those spaces in which it had meaning, and even the possibility of being an artist. However, the position of women in Orientalist discourse is heterogeneous ("an uneven matrix") and usually ambiguous: by assuming the male role of rendering the "Other," women artists are transgressive; yet, typically, this transgression is modified so as to reassert femininity. Ironically, women who were socially radical in being artists, and in traveling to the edges of the empire, often espoused conservative ideologies in their art either because they believed them or because they deflected from the transgression of being an artist. Thus, domestic genre scenes, portraiture and topography were favorite subjects. A naturalistic style also reflected

non-threatening bourgeois values. The common notion that women possessed a more perceptive understanding of others lent their art an "insider's" knowledge of—and greater sympathy for—their exotic subjects, even as this assumption also reinscribed the Western gaze as revealing the mysteries of the Orient.[4]

These ideas are directly relevant to Western female print-designers in East Asia during the first decades of the twentieth century. Keith, for example, matches the nineteenth-century norm outlined by Lewis. And, if flatness and decorative simplification can be interpreted as part of a strategy for more authentically representing East Asia, then Hyde and Lum also may be counted as relatively normative Orientalist female artists—their career-long repetition of highly romanticized images of women and children suggesting a feminized and infantalized Orient. Lilian Miller, in contrast, traversed a wide range of subjects and styles in the twenty years of her professional career, shifting her position to create in sum a richly ambiguous body of work within the spaces of Orientalist discourse.

### THE QUAINTNESS OF KOREA

IN 1920, AFTER THE CRITICAL SUCCESS at the Imperial Salon of her conservative ink painting *In A Korean Palace Garden* (figure 8), Miller turned to screen painting in order to translate her technique into a format more appropriate to display in Western-style rooms lacking a *tokonoma* alcove for hanging scrolls. She also seems to have favored more commercially-viable subjects. However, judging from the appearance *Bamboo in Snow* (figure 9) and the paucity of other screens, these works succeeded neither aesthetically nor commercially. Miller then began to produce woodblock-printed cards (figures 10 a-g & 26 a, b) and loose prints, working with the carver Matsumoto and printer Nishimura Kumakichi II. In contrast to her paintings these images sold well and, as multiple originals, provided Miller with a product that guaranteed financial and artistic independence. The cards and prints primarily feature Korean figures but

**Figure 26 a**
*Camellia and Pine on Table,*
undated card.
CATALOG 36 a

**Figure 26 b**
*Korean Junk,*
(variation copy),
undated card.
CATALOG 36 b

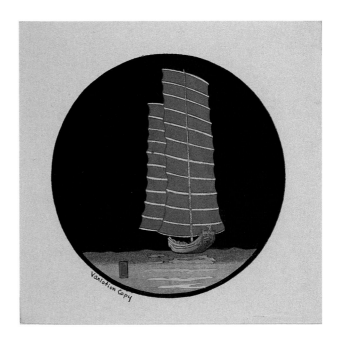

45

include a few other subjects. *Morning Snow on Bamboo* (figure 27) adapts the rather awkward right-panel of *Bamboo in Snow* into a more successful composition. Despite Miller's presentation of the print with the line "The spirit of the artist lives in the tip of the brush,"[5] her brilliance lay not in brushed pictures but in the translation of her designs into the printed images.

These cards and prints were aimed at the market of Western diplomats and businessmen—and their wives, most critically—living in large East Asian cities. The high copy number on many prints indicates that Miller perhaps made, and sold, as many as two- or three-hundred copies of each work. (The Great Kantô Earthquake and fire of 1923 destroyed the bulk of this production.) When Miller displayed the prints at private exhibitions in such locations as the American Embassy in Tokyo, she included hand-written prose descriptions for each work. Accompanying these short narratives are small pen sketches in the loose style made popular at the time by Ernest H. Shepard, illustrator of children's books by A. A. Milne and Kenneth Grahame.

In many ways Miller treats her Korean subjects with the same paternalistic care, the "sympathy and understanding," displayed by these authors and illustrators toward the small animals in their stories. As with the story-book worlds of Winnie-the-Pooh or Ratty and Mole in *The Wind in the Willows,* Miller's Korea is largely a land of enchantment stocked by magical characters who live in a time and place beyond reach except through the creative powers of the author and illustrator. This exoticizing nature of Miller's early work was lauded in contemporary reviews. In 1921 John S. Happer praised Miller for capturing "The hermits of the 'Hermit Kingdom' [who] will soon lose their quaint picturesqueness, as already the bowler and the frock coat are replacing the national costume."[6] Quoted in a 1923 article, Miller explained: "In 1917 I saw Korea for the first time. It seemed to me a story-book land. The people are like old Chinese sages with their long flowing garments of white, always white, and the men with their odd little black hats." Miller's Western audience is clarified in the same article when the author states that Miller "is doing her share toward interpreting the spirit of the East for the people of the West."[7] Another newspaper report underscores the importance of the texts to the images: "The prints depicting Korean kiddies proved the most popular among the Embassy women. And no wonder when they are accompanied by [such] explanations...."[8]

Miller's initial approach to Oriental images, and her intent to charm a Western audience is most evident in her text for *[Hunt for] The Scarlet Slipper* (figure 28):

**46**

**Figure 27**
*Morning Snow on Bamboo, Japan A* (gray background), 1920.
CATALOG 59

**Figure 43**
*Morning Snow on Bamboo, Japan B* (mica background), 1928.
CATALOG 60

**Figure 28**
*[Hunt For] The
Scarlet Slipper,*
1920.
CATALOG 41

**Figure 29**
*By The Little Green
Gate, Korea,* 1920.
CATALOG 42

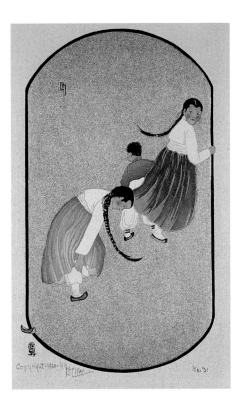

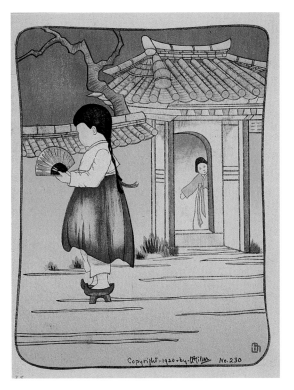

*Two little Korean girls come hurrying past me along a winding alley.
"They must be going to a feast," I thought to myself, "for they are in such
clean white jackets and pretty colored skirts. And Little Brother is in his
best white trousers and gayest jacket, and they all three seem so pleased
and excited." Just then the little girl nearest me slipped and lost her gaily
decorated little scarlet shoe. "I-qu, I-qu," she exclaimed anxiously, "I have
dropped my worthless shoe! Honorable Sister, pray wait one little moment."
Honorable Sister slackened her hurried footsteps and the little shoe being
retrieved, the trio went happily on together. Perhaps the end of their story
is that they arrived at their destination and had a festive time together
feasting on a great multitude of delicious cakes. But the end of <u>my</u> story is
that they kept haunting the mind of the artist. . . . their bright skirts and
that little scarlet shoe dropped off and lying in the middle of the street. So
I have transferred them onto paper and here they are for you to enjoy also!*

The print is the most abstract of the works from 1920 with spatial disjunctions result-
ing from the absence of a ground plane and the protrusion from the framed picture
plane of one sister's hand and the lost scarlet shoe. The lack of "real space" relocates
the entire event from the realm of actual children in Korea to the "mind of the artist."

   While admitting that her imagination subsumes the actual narratives of the chil-
dren, by no means does Miller dismiss the "thoughts" of the children she depicted. In
her essay for *By the Little Green Gate* (figure 29) Miller assumes the identity of a young
Korean girl (the ultimate act of colonial hubris or an extreme act of empathetic self-
abnegation) in order to explain the plight of most Korean females:

*My name is "Little Blossom," and I am a favorite with my august father.
This is because I have many brothers and my coming as a girl into this
world was not as unwelcome as that of most little girls in Korea. And so
instead of calling me "Little Rat" or merely by number, my parents gave*

**47**

*me a pretty name and today my honored father has even let me have his*
*fan to hold until he is ready to take his august departure. The little green*
*gate leads to another courtyard, and beyond that is my home. My father*
*is wealthy so we have several courts and colored gateways and in them*
*I play happily . . . but there is my mother calling for me. I must run*
*quickly and give my august father his beautiful fan, that he may*
*cool his cheeks with its soft breath on his way to an honored friend's.*

Although the reader learns of the low status of women in Korea, Miller emphasizes the positive condition of "Little Blossom," thus creating a favorable view of Korean customs despite the fact revealed. For the viewer of the print alone, the image is wholly winsome.

In *Monday Morning in Korea* (figure 30) Miller presents an image long on charm as a woman attempts to hang laundry in a strong wind while children play in the background. The text, however, suggests that doing laundry is a far from pleasant task:

*In my country the people wear their garments white, winter and summer.*
*This is an ancient custom of ours dating from a distant and troublous*
*age when the whole land mourned for three times three years because of*
*the death of three successive august rulers. At the termination of the long*
*period the people had become so accustomed to the white of mourning*
*that they continued to wear it as being more economical than constantly*
*changing their garments at each new death in the Imperial Household.*
*Even edicts subsequently forbidding the constant use of white has [sic] not*
*shaken its popularity with the nation. But these same white robes make*
*long hours of labor for the women of Korea. To wash the suits of our*
*fathers, husbands and sons is our constant task. Today I have finished*
*my share of washing and am hanging it to dry in the strong wind that*
*comes from beyond the purple mountains. But tomorrow again I shall*
*have still other garments to wash. . . . see my three small sons are playing*
*in the dirt! For Monday mornings comes <u>every</u> morning for Korean*
*wives and mothers!*

48

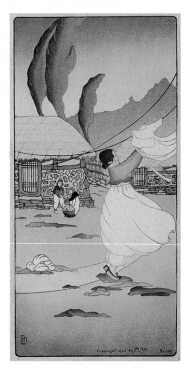

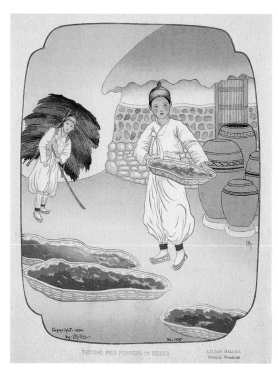

**Figure 30**
*Monday Morning
in Korea*, 1920.
CATALOG 43

**Figure 31**
*Drying Red Peppers
in Korea*, 1920.
CATALOG 44

Text and image together suggest Miller's ambivalence toward her subject: her text reveals Miller's understanding of the rigor of women's lives; yet, her desire to create art salable in the foreign community transforms the hardship of daily laundry into a picturesque image.

In the text for *Drying Red Peppers in Korea* (figure 31) Miller again takes on the persona of her subject, this time to explain the Korean custom of eating kimchee:

> *In the fall of the year, when the skies are cloudless, the air like crystal,*
> *and the sunshine beats down warm and mellow, we gather the red*
> *peppers together in great heaps, then spread them out to dry in low, wide,*
> *handwoven baskets. Wherever the sun shines warmest, there the peppers*
> *are spread. For peppers, Honored Stranger, are an important part of our*
> *diet. The winters in our country are long and bitterly cold and so, on our*
> *heaping bowls of rice, we eat a pickled relish of chopped vegetables brewed*
> *and seasoned with red peppers which warms our stomachs and hearts against*
> *the keen-fanged winds of the snow months. When the peppers are dried, and*
> *our other farming chores are finished, we shall sit and watch the women make*
> *the pickle-relish. They will chop and pound and do much mixing and in the*
> *end put it all into these great grey earthenware jars in our courtyard. There*
> *it will keep all the year and give us warmth and cheer with each bowl of rice.*

By focusing her print on the contributions of young boys, Miller creates an image more compelling than the recitation on kimchee production offered in the text. However, the pose of the boy in the center, directly engaged by the viewer's gaze, underscores the fact that his quaint speech is offered to the "Honored Stranger." Both image and text put Korean customs and people on display—as if in an anthropological exhibit— for the "honored" foreign presence. Stylistically, this work, like so many of her 1920 prints, stresses description over mood or formal structure in its emphasis on narrative.

Miller's propensity to speak for her subjects extends to Japanese figures as well as Koreans. In *Tokyo Coolie Boy* (figure 32) she invents a story to explain the boy's daily activities as well as to proclaim his satisfaction and his spirituality:

**Figure 32**
*Tokyo Coolie Boy A*
(gray sky), 1920.
CATALOG 53

**Figure 33**
*Woman Under*
*Umbrella,*
ink on paper,
ca. 1920.
CATALOG 34

49

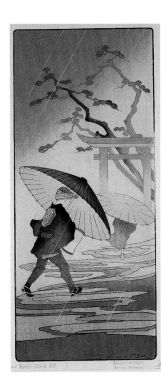
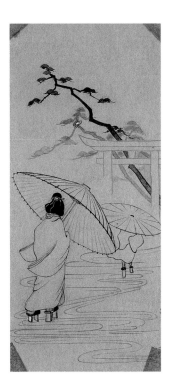
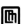

*I am a little coolie messenger boy. All day in the rain I have been running errands for my master, who owns a small lacquer shop. My last task this evening was to take a beautiful lacquer bowl to a great house where a kind hearted lady gave me twenty sen to keep—hence I am homeward bound with a smile upon my face. Homeward to a dinner of delicate steaming rice with hot amber colored tea and a few tart pickles to give edge to my humble repast. But for all my hurry I must not forget to stop by that temple gate in front of us—just long enough to twist the tinted streamers that hang from the bells above the steps leading to the shrine and slap my hands together softly—that I may draw the kind eyes of the Great Lord Buddha down towards me and make him graciously attend to my little evening prayer.*

In the original drawing for this print (figure 33) the "coolie boy" is a woman perched on high-*geta* and clad in a long-sleeved *furisode* kimono. Miller may have changed the gender of the figure to better fit purposes of design and narrative, or to distance the print from its models. *Tokyo Coolie Boy* demonstrates Miller's indebtedness to the styles of two main predecessors among female print designers in Japan: a child bent under a large umbrella had been rendered several times by Helen Hyde—most notably in *The Family Umbrella* of 1915—while the swirling pattern of the water, distant figure in silhouette, red *torii* and spectral trees all derive from Bertha Lum's prints—particularly *Temple Gate* of 1912.

**Figure 34**
*By the Great
River Han*, 1920.
CATALOG 45

**Figure 35**
*By the Great
River Han*,
undated.
CATALOG 46

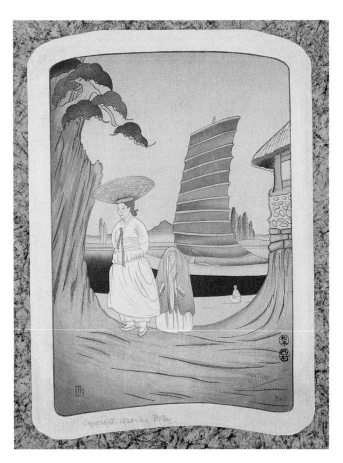

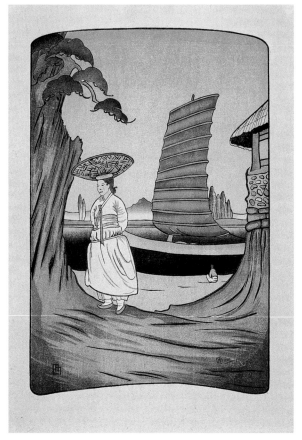

In *By the Great River Han* (figure 34), one of her most popular early prints, Miller again adopts the narrative voice of a boy:

> *Down at the end of our village street there is a sloping hill leading to the beach by the great, smooth-flowing river of the Han. Along this noble highway pass picturesque junks and here I like to sit and watch their richly tinted sails swing slowly by. Sometimes the sails are an orange faded by the hot Korean sun, but when they are new they are often a rich tone of terracotta, very pleasing to the eye against the browns and greens of the distant bank. My mother is just coming up the hill, carrying a basket of washing on her head from where she has been doing her laundry work on the river bank. Behind her is my sister, with a green coat over her head to cover her face; for she is young and it is not proper that the eyes of strange men should rest upon her face. They are leaving me behind on the beach, for I cannot tear myself away from the river or the junks . . . perhaps still another one will soon sail by like a great crimson bird.*

While the image centers on the mother returning from the river, the text shifts the focus to the thoughts of the boy who is but a minor figure in the print. Here Miller's words suggest that the Koreans in the print are not merely the objects of the Western gaze, but are individuals who control their own gazes and hence their imaginations and potential for esthetic pleasure. (It should be noted that the sister with the green coat over her head, adapted from one of the small greeting cards [figure 10 d], appears in a print dated 1920 but is absent in an undated print [figure 35] presumably from a later date.)

The River Han and its junks also form the basis of *Orange-Sailed Junk of the Han* (figure 36), which adapts the subject and composition of Lum's 1912 *Pines By the Sea* as well as reprises images from two of Miller's cards (figures 10 a and 26 b). Because of the absence of figures here, both print and text focus on the ship and its cargo:

**Figure 36**
*Orange-Sailed Junk of the Han,* 1920.

CATALOG 47

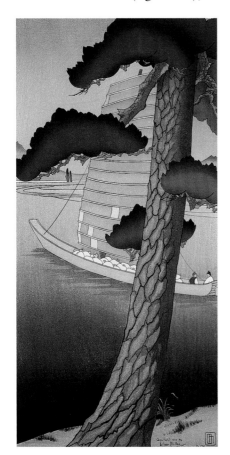

> *The Han is one of the great rivers of Korea and its stately waters are a constant highway for native commerce. Here the junks pass up and down its winding course, laden with rice and other agricultural produce on their [way] down and carrying perhaps strange but useful articles from foreign devil countries on their return. These junks have sails dipped in a preservative which turns them to a rich terracotta which weathers gradually to deep orange; and when they are glimpsed down through the trunks of some pine grove, just as the setting sun is tingeing them with its vivid rays and making them glow against the deep, smooth green of the water, then does the name of a little shrine half-hidden among the pine trees seem most truly fitting:—"Temple of the Flowery Stream."* [10]

The text is largely descriptive with one exception: by mentioning "foreign devil countries," Miller acknowledges the tension between Asian nations and foreign colonizers but simultaneously casts this critique as part of the picturesque scenery of the East. In short, while the Western viewer is absent from the image, she or he is interjected into it upon reading the text.

The appeal of these prints is indicated not merely by the number produced but by the reproduction of four images, with texts, in

51

**Figure 37**
*Father Kim
of Korea* (yellow
background),
1920.
CATALOG 55

Nadia Lavrova's 1923 *San Francisco Chronicle* article "Vassar Girl Portrays Hidden Beauty Of Korea In Color." Lavrova comments on the whimsy of the texts and defines Miller's mission in life as "exhaling beauty." For *Father Kim of Korea* (figure 37) she attaches the poem "The Mission of Old Father Kim," written by M. P. Starret and dedicated to Miller:

> *The world would call me poor . . . but there I smile. Could any treasure be more real than simple tastes and a kindly heart? I spare the world inconvenience in the one and give it all of the other. A happy American girl has painted me . . . no one else could. She has caught my smile and portrayed my spirit. Do you surmise that she is hurrying me to work? Ah, dear reader, little must you know of the ways of my country—it has ever been called "The Land of the Morning Calm". More tobacco is my mission.*

The overt condescension in Starret's text points up the restraint in most of Miller's own writings, and contrasts with Miller's more respectful rendering of the man. Yet it also suggests how many patrons may have viewed this and other images. Moreover, that Miller copied out these lines when she displayed the print demonstrates her complicity with this view of Oriental lassitude. Indeed one of her greeting-card prints (figure 10 c) features a white-bearded man smoking a pipe. While the ideology behind, or around, the print is standard-issue Orientalism, the cut-off composition and placement of the figure against an abstract background shaded from yellow to orange constitute one of Miller's most-accomplished early designs.

According to the 1921 article in *The Far East* magazine, in that year Miller began work on the series "People We Pass" featuring "typical Korean types, the brilliant coloring of the costumes to be intensified by a black background." In *On the Way to the Brushwood Market* (figure 38), presumably from this series, Miller provides a lengthy treatise on the economy of Korean heating which leads eventually to the pictorialized vision:

> *The Korean people live in houses with baked floors. Under them run long flues, leading out from a primitive stone fireplace outside one end of the house to separate exits at the other, so whenever a fire is built the smoke makes its way through the various flues and heats the floor, giving the rooms a very comfortable temperature even on a cold day. For fuel pine brush is usually used and it is a very common sight in the streets of any Korean town or village to see placid old bulls being led along almost completely hidden under huge piles of cut pine boughs. Cut on the neighboring hillsides, this brush is piled onto the patient animals and brought each day to the big brush market which is in every town. And every road is dotted with any number of moving masses of green and brown visibly supported on only four hoofs; but when the mass swings around in answer to some shouted imprecation of the white-robed peasant owner, you will catch a glimpse of the supernaturally solemn, patient, decorous old bull, sole support of his towering burden.*

**Figure 38**
*On the Way to the Brushwood Market, Korea*, 1921.
CATALOG 49

**Figure 39**
*The Quaintness of Korea*, 1920.
CATALOG 48

The description of Korean customs seems innocuous enough, yet read in the context of other images and their accompanying texts, and within the colonial environment in which Western powers and Japan vied for influence in Korea, these images of charmingly backward Korea participate in the ideology of Orientalism.

At times, however, Miller seems clearly to modify the discourse that looks with a knowing smile upon the rusticity of Koreans. The essay for *The Quaintness of Korea* (figure 39) presents an extended narrative in the character of the woman pictured:

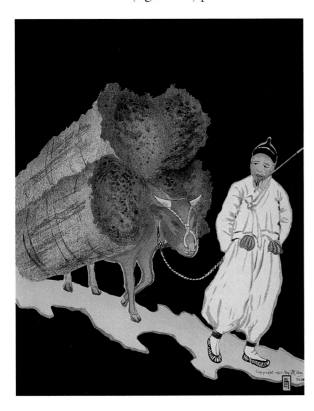

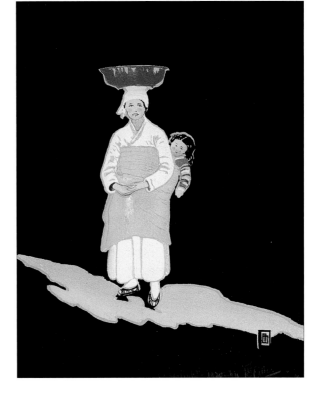

*It is only very rarely that good water may be had in our mud and stone houses of Korea; so that to get any I must walk "three pipefuls down the street" (in the language of our tobacco loving people) to where there is an iron pump inside of which the waters of the distant river, bewitched by foreign devils, have been miraculously made to rise and flow forth at the turn of a hand. I am on my way there now, my earthenware bowl perched jauntily on my head, and with me goes my little son, the pride and blossom of my heart, strapped onto my back with a green wadded quilt to keep his little body warm. He has on a little jacket that I made him, with sleeves of bright stripes of many colors, cut from a treasured store of odd bits of silk. But I must not stand and gossip too long. . . a Korean woman must work hard and long and patiently. Yet our smiles are as cheerful as those of the great ladies of foreign lands, whose lives seem to us to look like soft white lotus flowers unhampered by the cheerless drudgery that calluses our hands and stoops the strongest of our backs.*

There is no denying that Miller's comparison of the "cheerless drudgery" of Korean women's lives with the pampered existence of the Western women serves in part as a rebuke to her own culture. While the image traffics in Orientalist discourse—clearly evident in the title *The Quaintness of Korea*—Miller is also aware of a typical Korean woman's reaction to the unequal power relationship between colonizer and colonized. In this light, the image, for all its stark simplicity of form, becomes richly ambiguous: is this woman simply receiving the controlling gaze of the viewer charmed by her quaint ways and sympathetic to her toil? Or does she return that gaze thereby implicating the viewer and acknowledging, though not directly threatening, the colonial equilibrium?[11]

In the case of *The Quaintness of Korea*, the text suggests a reading which complicates and enriches the print. Yet, even without a text, Miller's prints may be ambiguous, read differently by viewers based on their experience or desire. No essay has been found for the untitled and undated print of a small girl seen from the back (figure 40). However, a commentary on this work by Stewart Teaze, an American businessman resident in Tokyo in the 1930s and a serious student of popular prints, demonstrates the difficulty of assessing actual subjects much less their "meaning"—thus it signals the danger of one-dimensional and overly-determined readings. Despite the fact that the child wears the plum-patterned kimono, red *geta* and *kariage* hairstyle of a girl, Teaze placed this print of a "boy" in his son's bedroom because "there is a sturdiness about the youth which is forceful and symbolic."[12]

**Figure 40**
Untitled (Young Girl from the Back), undated.
CATALOG 50

However widely viewers may disagree in reading particular prints, these images collectively are alike in presenting Korea and Japan as eternally pre-modern—the traditional cultures of these lands forever cast as their essential form. And in this frozen state they are forever beautiful and peaceful—qualities which distinguish them from the increasing dirt and din of the industrial West. This conceptual core of Miller's early work, the binary opposition between East and West, is found in equal measures in the image and the text for *Moonrise Over Ancient Gateway* (figure 41):

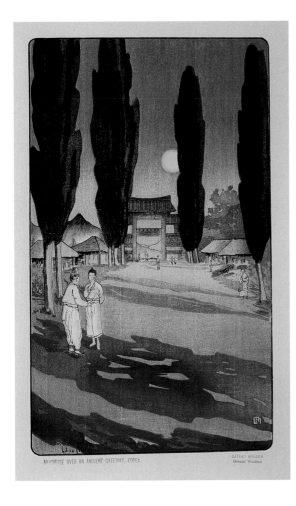

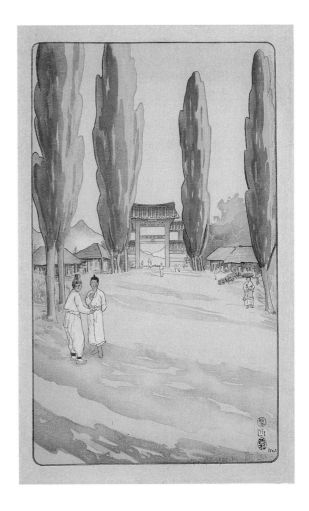

**Figure 41**
*Moonrise Over*
*Ancient Gateway,*
*Korea*, 1920/21.
CATALOG 51

**Figure 42**
*The Gateway of*
*the Purple Hills,*
*Korea*, 1921.
CATALOG 52

*Down the length of a typical Korean village runs a broad country road,*
*guarded on either side by tall poplars that rustle with a silken whisper in the*
*evening breeze. At the very end of the village stands an ancient gateway, once*
*an entrance to the palace of some powerful 'yangban,' or Governor, now a*
*dwelling place for the flickering bat and velvet-winged moth; yet still beautiful,*
*with the iridescent hills of Korea glimpsed through its spacious archway. As*
*the dim afterglow of the vanished sun throws tapering poplar shadows across*
*the road, and the summer moon rises from its purple nest behind the mountains,*
*the people of the village come from their evening bowls of rice to enjoy the cool*
*air and hold pleasant converse with their neighbors. There is always a cool*
*tranquillity, an unhurried peace, about such Korean evenings, as if the*
*many sleeping centuries which have passed over this picturesque land left*
*something behind them of their mellow and age-old serenity.*

**55**

The print seems to have been issued originally in 1920 as a daytime scene entitled *The Gateway of the Purple Hills, Korea* (figure 42). The standard version, with purple evening sky and full moon, creates the mood of "unhurried peace" which marks Korea's "sleeping centuries." Here, by locating the Orient as an eternal past unable to overcome its own inertia, and then regenerating this condition as its preserver, Miller performs some of the conceptual maneuvers central to Orientalism. In sum, Miller's prints of 1920 and 1921 construct a vision of the Orient which parallels those of her slightly older contemporaries Hyde and Lum. For Miller this initial interpretative stance as well as working method (using a professional carver and printer) were to change only after a long battle with disease stilled her artistic creation from 1923 to 1927.

## CREATIVE PRINTS

WHEN MILLER BEGAN AGAIN TO MAKE ART in 1927 she did so with a burst of energy, making several dozen prints to display and sell on her 1929-30 tour of America. In addition to these new designs, Miller pulled new prints from the blocks of some of her most popular early works. She also created alternate versions for several of these compositions, recoloring some blocks to produce color variations. For *Morning Snow on Bamboo* (figure 27) Miller reprinted the background block and covered it with mica (figure 43, *see page 46*). In the case of *Tokyo Coolie Boy* (figure 32), originally rendered with a gray background and mica for the streaks of rain, she now used blue on the background block (figure 44, *see page 6*). And, for *Father Kim of Korea* (figure 45, *see page 9*), Miller deployed a light blue background, changed his shirt color from blue to yellow and the tassel on his tobacco pouch to red from blue. The earlier popularity of the Father Kim subject further resulted in the creation of two new prints— *Father Kim on Muleback, Korea* with yellow or blue backgrounds (figures 46 and 47)—adopting the image from a 1923 Christmas card of a similar man clutching a pipe while astride a mule (figure 10b). While the subject is the quaint denizen of the "Hermit Kingdom" who inhabited her early prints, the creation of two dramatically different color versions subtly shifts the emphasis here from a picture about a genre subject to a design which deploys that subject. In essence, the 1928 Father Kim prints become formal plays in tone and texture even as they maintain the exotic Oriental subject appealing to many viewers in Japan and America. Moreover, for an artist increasingly cognizant of the need to sell her work, two color states of the same design not only gave Miller an easy way to create more "product" but also meant that some collectors would buy both images.

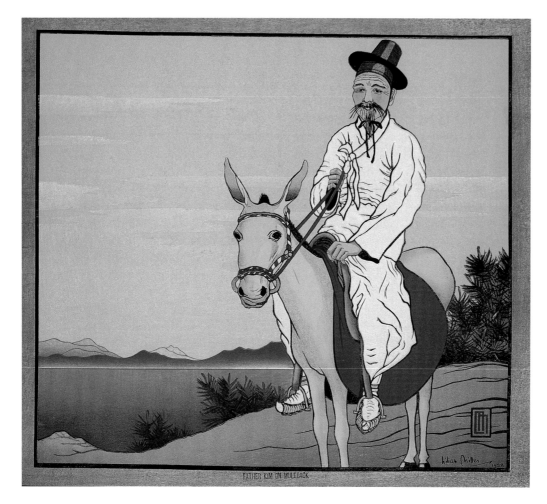

**Figure 46**
*Father Kim on Muleback, Korea* (yellow background), 1928.
CATALOG 57

This shift in the appearance and conception of Miller's work was brought about by a fundamental change in the process of production. Instead of making a design then turning it over to a carver and printer working under her supervision, Miller mastered the requisite carving and printing techniques. It is impossible to say whether this new intimacy with process led to her growing interest in formal effects, or if it is this interest which brought about her involvement in production. Nonetheless Miller's personal exploration of the carving and printing processes is directly felt in the final products. Harriet Miller Cooper describes her sister's connection of method and effect:

> *She not only creates her original pictures, but actually cuts the blocks and makes the prints herself. This has enabled her to obtain unusual effects: a wider and more vivid range of color, use of shadows, an added depth and mellowness of shading achieved by repeated printings, and variations of the same picture by using different colors to indicate differing seasons or moods. All of these things would have been more difficult for any artist to obtain who had to be content with the old methods of Japanese printers and their reluctance to change.*[13]

Miller's commitment to the carving and printing processes as the basis of her new work was so strong that technical demonstrations were the centerpiece of her lecture tour, as described in Miller's 1933 *Vassar Quarterly* article "An American Girl and the Japanese Print." In terms of Miller's negotiation of gender roles, in Japan where this craft was the exclusive province of men, Miller's production of her own prints was an inherently transgressive act. Yet, in the West, where craft work was increasingly associated with bourgeois femininity, Miller's carving and printing may well have been read as appropriately feminine behavior.

**Figure 47**
*Father Kim on Muleback, Korea* (blue background), 1928.
CATALOG 58

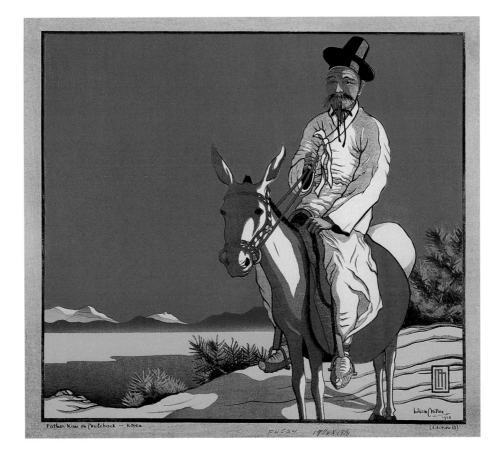

57

Despite Miller's claim to preserve old processes, she was surely aware of the debate swirling through Japanese print circles of the 1920s and early 1930s between *shin-hanga* (new prints) artists who, in the traditional manner, had artisans carve and print their designs, and the *sōsaku-hanga* (creative prints) artists who ostensibly carved and printed their own work, often claiming to express the spirit of Japanese craft.[14] Miller's *Hongkong Junk* (figure 48), one of the designs used in her demonstrations, exemplifies this *sōsaku-hanga* element in her work. Some versions feature a gold moon, others a silver disc, and a variation copy leaves out the orb altogether to suggest the junk at noon. Beyond mere chromatic variation, the simplicity of design, boldness of color, and powerful lines reveal the primacy of process—an

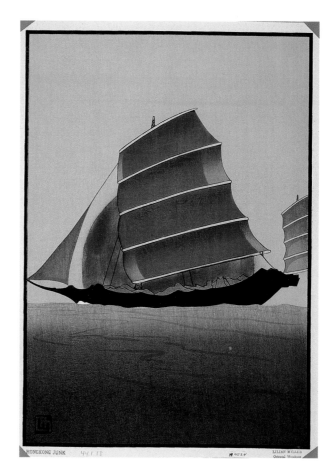

**Figure 48**
*Hongkong Junk,*
1928.
CATALOG 61

effects noted by a 1931 *San Francisco Chronicle* reviewer as "transcendently lovely" "color harmonies" and the "formal aloofness" of "square outline junks."[15]

Miller's most dynamic exploration of the dramatic formal effects achievable by radical simplification of subject, color variation and the hard-edges resulting from blunt block carving appears in six prints of the famous Diamond Mountains in different seasons and times of day. The *Diamond Mountains, Korea* series, comprised of *Spring* (figure 49), *Summer* (figure 50), *Autumn* (figure 51), *Autumn Evening* (figure 52), *Winter* (figure 53), and *Snowy Morning* (figure 54), centers on a design of two rocky peaks likely derived from a photograph Miller took of one spot in the mountains. Upon this basic structure Miller overprints green blocks for *Spring*—overprints blue for *Summer*; adds a block to create striations in the orange sky as well as orange-brown-red coloration for *Autumn*; substitutes a light orange sky with gray mountains and a new block for the "mist" at the mountain base for *Autumn Evening*—eliminates the striated block to create a gray sky and then uses white and dark gray (reversing the positive and negative forms of the other prints) to suggest the snow-covered mountains for *Winter*—and, finally, adds a vivid orange striated sky to the *Winter* scene to create *Snowy Morning*. Despite the cleverness of the color variations and the striking appearance of the whole series—which recalls several of Hokusai's prints from his *36 Views of Mt. Fuji* series and Yoshida Hiroshi's tour de force *Inland Sea* series from 1926—Miller's *Diamond Mountains* series seems to have sold poorly. The price list for the 1929 exhibit at the Gordon Dunthorne Gallery has each print at $15, by far the cheapest of the prints made in 1928 and only slightly higher than the $9 and $12 asked for most of the 1920 prints. By 1941 the series fell to the bottom of Miller's price list at $3, while some technically complex and romantically naturalistic prints from 1928 retained prices of $25 to $50.

The commercial failure of the *Diamond Mountains* series likely stemmed from

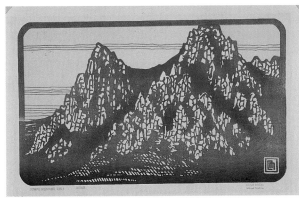

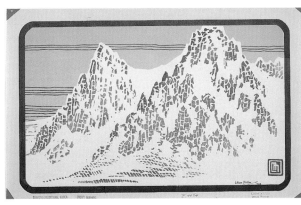

**Figure 49**
*Diamond Mountains,*
*Korea, Spring,* 1928.
CATALOG 62

**Figure 50**
*Diamond Mountains,*
*Korea, Summer,* 1928.
CATALOG 63

**Figure 51**
*Diamond Mountains,*
*Korea, Autumn,* 1928.
CATALOG 64

**Figure 52**
*Diamond Mountains,*
*Korea, Autumn Evening,*
1928.
CATALOG 65

**Figure 53**
*Diamond Mountains,*
*Korea, Winter,* 1928.
CATALOG 66

**Figure 54**
*Diamond Mountains,*
*Korea, Snowy Morning,*
1928.
CATALOG 67

**59**

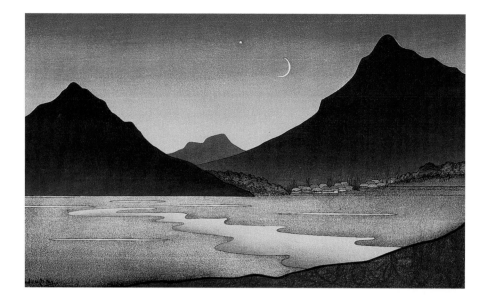

**Figure 55**
*"The Crescent Moon Rides Low," Korea,* 1928.
CATALOG 68

**Figure 56**
*Korean Farmhouse by Moonlight,* 1928.
CATALOG 69

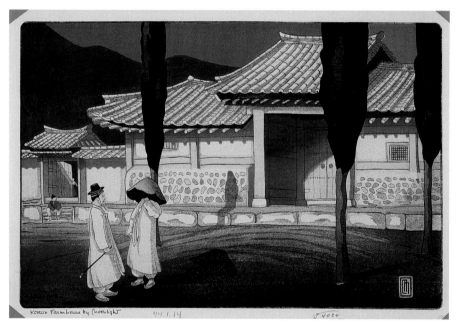

their lack of narrative and "local color" together with the relative abstraction and minimal production values. In most of her prints from 1928 Miller explores a middle path synthesizing the formal exploration of these images with the exotic subjects of her work from the early 1920s. This mix of romantic scenery with lush tones and textures is also the most salient characteristic of Miller's poetry as published in *Grass Blades from a Cinnamon Garden* of 1927. In fact, the print *"The.... Crescent Moon Rides Low," Korea* (figure 55) visualizes Miller's poem "The Golden Junk" from *Grass Blades:*

> *Over the soft blue stretches of the plain*
> *Where the crickets weave their wistful evensong,*
> *And the cool night-fragrance of the shadowed earth*
> > *Freshens the jaded breeze,—*
> *Lo, a crescent moon rides high with tilted prow,*
> *Like a gleaming golden junk against the dusk,*
> *Like a shining golden junk against the night,*
> > *Gliding through cobalt seas.*

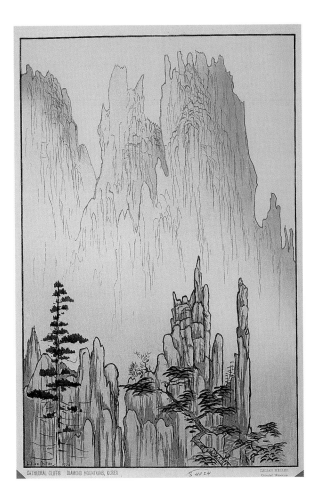

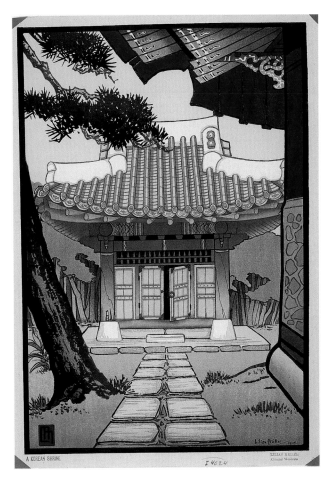

**Figure 57**
*Cathedral Cliffs, Diamond Mountains, Korea,* 1928.
CATALOG 70

**Figure 58**
*A Korean Shrine,* 1928.
CATALOG 71

The tonal surface of the poem is evoked in the dark saturated blue of the mountains shimmering between the gray-green hillside in front and the lambent glow of the sunset behind. The crescent moon—the subject of the print's title and the poem—is very nearly irrelevant to both verse and image.

An instructive comparison can be made between the treatment of the similar subject matter in Miller's 1920/21 *Moonrise Over Ancient Gateway, Korea* (figure 41) and her 1928 *Korean Farmhouse by Moonlight* (figure 56). The subject, two Korean men conversing by moonlight beneath the poplars outside a large house, is the same in both works but the later print evinces a much stronger mood, achieved by the tonal richness of the overprinted blues and greens, and a more abstract composition based on the rhythm of the horizontal and vertical forms set against the diagonals of the roof. The shift in sensibility is also evident by the fact that the background figures are the real focus of attention in the early print, while in the later print it is only on second or third viewing that one is liable to notice the two small figures at left.

While space, tone and texture are perhaps the primary areas of Miller's formal exploration, she also investigates the properties of line and composition within images which seem at first glance to be naturalistic renderings of observed scenes. In *Cathedral Cliffs, Diamond Mountains, Korea* (figure 57) Miller presents a series of needle-like spires rendered with subtly modulated outlines suggesting the translation of a brush painting into the print medium. Comprised solely of unconnected foreground and background ridges of curvilinear, organic cliffs (with the exception of two pines, one arrow straight), the print contrasts formally with *A Korean Shrine* (figure 58). Here the scene recedes naturalistically along the walkway from the cut-off foreground elements to the shrine at the back, and all the forms—except the pine tree and the

**61**

foliage behind the shrine—are harshly rectilinear. Both prints depict real Korean scenes, but the absence of figures brings attention to the formal properties of these mountains or buildings. Nonetheless, for an audience primed to look at the Orient in terms of romantic beauty, *A Korean Shrine* evokes the mysterious religion of the East, while *Cathedral Cliffs* could well illustrate Isabella Bird Bishop's 1897 description of an area in the Diamond Mountains: "Great limestone cliffs swing open at times to reveal glorious glimpses, through fantastic gorges, of peaks and ranges, partly forest-covered, fading in the far distance into the delicious blue veil of dreamland."[16]

Miller's strongest prints combine a variety of striking formal effects even as they evoke the serene beauty of the Orient untouched by the modern world. *Nikko Gateway, Japan* (figure 59) depicts the site of Miller's childhood summers—experiences recalled in a poem singing of ". . . the scarlet gleams/Of thy lacquered shrines where tall pines stand apart/To give green, solemn vistas,—how they rise/Dream-like before me!"[17] The print, for all its nostalgic beauty, is a study in contrasts: the verticality of the tree trunks plays against the horizontal wall; the biomorphic foliage balances the geometric tree trunk and gate; and the red and green are all the more vibrant for the gray and brown. Most of all, the print is dramatically spatial and tactile: the striations of the tree trunks, the tour de force *gomazuri* (sesame grinding) effect on the flat

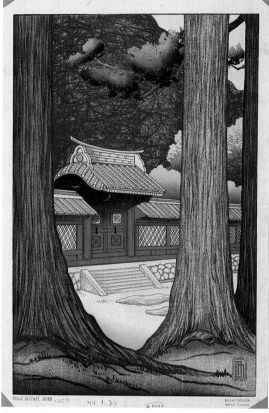

**Figure 59**
*Nikko Gateway, Japan*, 1928.
CATALOG 72

hillside, and the multiple textures of the three-dimensional wall and gate form a striking array of volumes and textures. In *Makaen Monastery, Diamond Mountains, Korea* (figure 60) Miller depicts the Mahalyan temple "romantically positioned" on a cliffside in the Diamond Mountains, nestled among a grove of great fir trees and overlooking a panorama of huge peaks. The rough textures of the foreground foliage and the temple contrast with the smooth silhouette of the second tree (in front of the temple) and the distant precipice. To the right the tones shade from dark green to blue-green

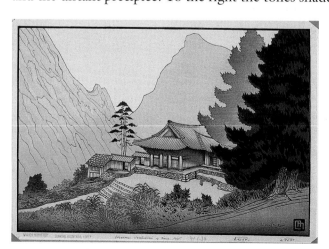

**62**

to gray while to the left they change from olive green to brown to yellow. The geometric forms of the temple at the center of the composition stand out against the organic shapes of the trees and mountains. In this rich mix of forms and colors, the scarcely noticeable figures of the two bowing monks emphasize how far Miller has come from the "charming figures" of her early prints.

**Figure 60**
*Makaen Monastery, Diamond Mountains, Korea*, 1928.
CATALOG 73

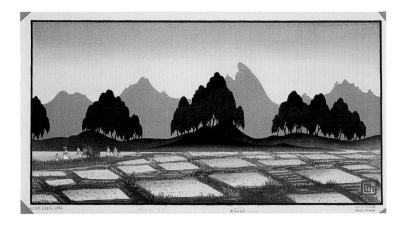

Figure 61
*Autumn Evening,
Korea*, 1928.
CATALOG 74.

*Autumn Evening, Korea* (figure 61) offers perhaps an even more compelling visual surface as the checkerboard pattern of the barren paddy field, set off by blue lines representing tall grasses, establishes geometric motifs countered by the gentle swell of the hills with ghostly groves of trees silhouetted against the background design of dramatically contoured mountains. The stubble of the field gives way to the soft gray of the hills and trees, then dissolves into the glassy smoothness of the distant peaks. Within this play of glowing natural forms, a band of farmers trudges home—a note of transient humanity underscoring the eternity of nature. Despite the abstraction of Miller's vision, any rendering of Oriental life is easily read in narrative terms—as indicated by Joan Grigsby's poem "Autumn Evening, Korea" published with the print in *Asia* for November 1931:

> *Wan are the rice fields in the dusk tonight.*
> *Far off I hear the cranes' regretful cry*
> *And watch their wings outspread against the light*
> *That fades while day grows shadowy in the night*
> *On glimmering fields beneath the pallid sky.*[18]

Where Miller's texts help flesh out the narrative quality of her early prints, Grigsby's lines—including three more stanzas—add nothing to the image.

Perhaps Miller's only prints almost completely resistant to narrative interpretation are her bonsai prints: *Japanese Dwarf Plum Tree* (figures 62 and 63), *Japanese*

Figure 62
*Japanese Dwarf
Plum Tree A
(black background)*,
1928.
CATALOG 75

Figure 63
*Japanese Dwarf
Plum Tree B
(gray background)*,
1928.
CATALOG 76

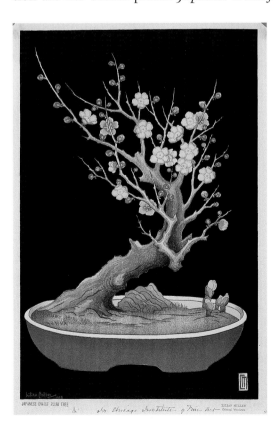

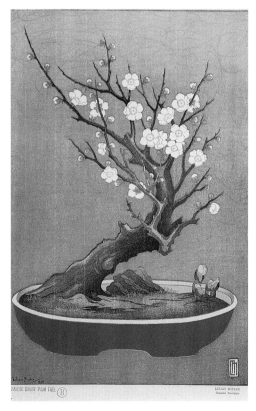

**6 3**

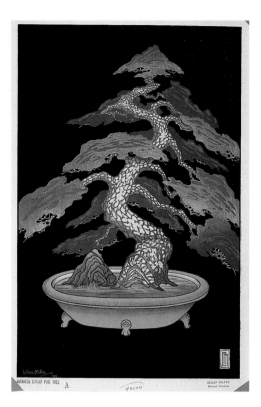

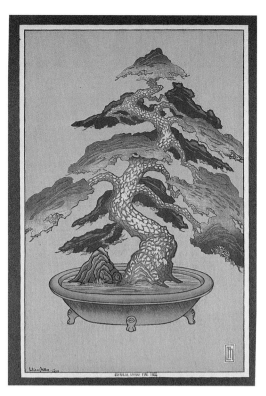

**Figure 64**
*Japanese Dwarf
Pine Tree A
(black background)*,
1928.
CATALOG 77

**Figure 65**
*Japanese Dwarf
Pine Tree B
(tan background)*,
1928.
CATALOG 78

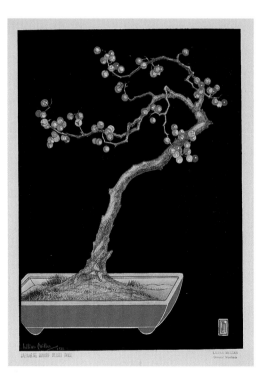

**Figure 66**
*Japanese Dwarf
Berry Tree*, 1928.
CATALOG 79

**Figure 67**
*Japanese Dwarf
Berry Tree
(gray background)*,
undated.
CATALOG 80

*Dwarf Pine Tree* (figures 64 and 65) and *Japanese Dwarf Berry Tree* (figures 66 and 67), each produced with black or gray backgrounds. In addition to the different tones applied to the reverse keyblock (or background block), Miller added a black outline to the tree trunks of the images with gray backgrounds. Moreover, the flowers of the plum are pink for the black background, and white for the gray—each color scheme chosen for maximum effect. While Miller had experimented with flat black backgrounds in the early 1920s, the bonsai images are more dramatic because the large size of the

potted plants produces a monumental quality in stark contrast to their dwarfed scale. The black backgrounds serve to push the images forward, while the gray backgrounds emphasize the texture of the tree trunks. The simplicity of the compositions highlights the technique of the block carving and printing—so skillful that it is hard to believe they were produced by Miller and not by long-practiced professionals. The stark contrast of subject and background in these prints, highlighting the naturalism of the plants even as it suggests their potential for abstract design, perhaps derives from Miller's study of Japanese design books. Miller may well have synthesized images from an anonymous and untitled Meiji-period album which includes both meticulously detailed flowers and flat floral patterns (figure 68).

The black background of the bonsai prints is utilized to even greater effect in the remarkable *Rainbow Phoenix Waterfall* (figure 69). The strange composition—built out of twisted shapes, with the famous cataract, adjacent cliffs, and bright fall foliage surrounded by a border of black—presents the view from inside a cave but may well be meant to suggest the body of the dragons which supposedly inhabit these famous pools. The work is about the interplay of form and color, with the pines in the upper part of the scene composed as either positive or negative shapes while the brilliant foliage patterns in the middle of the picture are created by areas of pure color, whether flat or mottled. Lines appear only on the waterfall and in the striations of the rock. In essence, the print is very nearly non-representational, its impact unchanged when rotated 90 or 180 degrees. This extreme formal exploration recalls the visual experimentation of Kamisaka Sekka (1866-1942) in his masterful, three-volume woodblock-printed book *Momoyogusa* of 1909-10. Miller owned the second volume and the two-page

**Figure 68**
*Anon, floral design album,* 1909, ink and color on paper.
CATALOG 21

65

**Figure 69**
*Rainbow Phoenix
Waterfall [Diamond
Mountains, Korea]*,
1928.
CATALOG 81

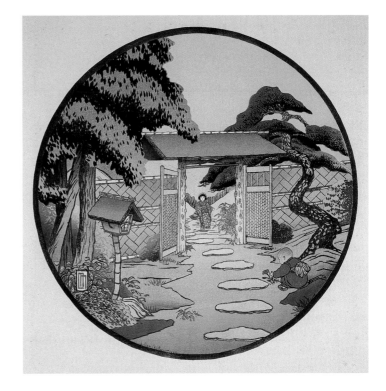

picture of Kikujido (figure 70), the magical Chrysanthemum Boy, represents the exaggerated viewpoint, simplified forms and "violent contrasts of color" of Sekka's best designs.

## SUNSET AND MOONLIGHT

Despite the innovation and beauty of these prints, for an audience interested largely in the exotic life of the Orient, such abstract scenes must have been but partially satisfying. Only a desire to please the "paying audience" can explain the banality of *The Garden Gate, Omori, Japan* (figure 71). The hackneyed theme and bogus charm bespeak a servile exoticism underscored by the careless composition and indifferent coloration. In 1929 the print was listed at $35, one of Miller's most expensive, but by 1941 it dropped to near the bottom of her list where, with many early figure prints, it was priced at $5. Even when playing to her audience's desire for pictures reinforcing fantasies of natural Oriental beauty and childlike passivity, Miller's typical prints of 1928 are more accomplished in their artistry and more subtle in their Orientalism.

In preparing for her 1929-30 American tour, Miller arranged to have an article on her work published in the mid-October issue of *Art Digest*. For the article she chose *Rain Blossoms* (figure 72) and provided this description:

> *Though Japan is now in the seemingly inevitable transition from an oriental county to an up-to-date Western power, there are still to be found, both on the highways and byways of Nippon, many reminiscent touches of her ancient picturesqueness. Amongst these perhaps one of the most beautiful is the gay tinted oil paper umbrella that rich and poor, young and old alike, may be seen carrying on rainy days. These quaint round umbrellas are not only of many colors but of many patterns, an endless succession of designs of breath-taking charm; and cloudy, gloomy days in Japan take on a bright and lovely aspect when two or more of these umbrellas are glimpsed passing down a lane or crossing over an old native bridge, looking like veritable blossoms opening in the rain.*[19]

**6 7**

The print reprises the umbrellas-in-the-rain theme from *Tokyo Coolie Boy* of 1920 (figure 32), reprinted in its "B" version (figure 44) in 1928. Miller similarly created two color variants of *Rain Blossoms,* with "A" featuring a gray background and "B" using a brown tone (figure 73). Despite the narrative appeal, Miller dramatically juxtaposes the naturalistic volume of the round umbrellas with the unnatural flatness of the silhouetted figures beneath them. The flat-figure motif appeared in the original *Tokyo Coolie Boy* but is wildly exaggerated here—an idea perhaps adapted by Miller from her copy of Ikkeisai Yoshiiku's late nineteenth-century book *Makoto no tsukihana no sugata-e* (figure 74) with its striking "shadow" portraits of famous actors beneath roundels bearing their conventional portraits.

The shadow-like silhouette is used most dramatically in *Korean Junks at Sunset* (figure 75), Miller's only diptych. The romantic image of junks along side a traditional Oriental structure, rendered in shades of ghostly gray against a brilliant orange sunset, surely

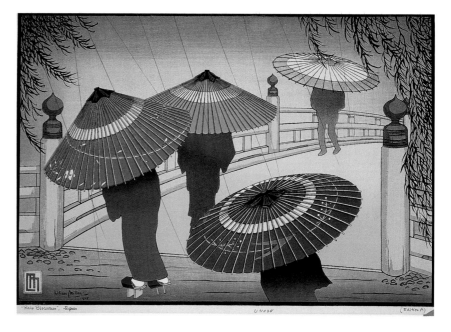

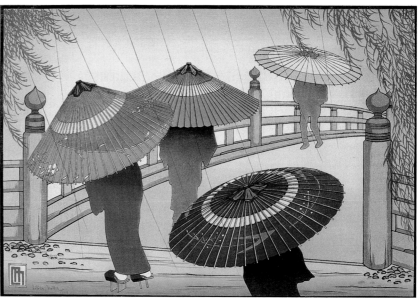

**Figure 72**
*Rain Blossoms, Japan, A (gray),* 1928.
CATALOG 83

**Figure 73**
*Rain Blossoms, Japan, B (brown),* 1928.
CATALOG 84

satisfied patrons desirous of possessing an image redolent of the romantic East. Despite the Orientalism evoked by the timeless beauty of Korea—or Japan, or China, the junk being one of the pan-national symbols for traditional Asia—the diptych is also satisfying as an exploration of the woodblock-print medium. Miller was certainly familiar with Yoshida Hiroshi (1876-1950), the most famous print designer of the period and, like Miller, an independent who published his own work. Miller owned at least two Yoshida prints and was surely aware of his famous 1926 *Sailing Boats* series in which the distinctive sails of junks, and their shadows on the rippling water, form the entire subject.[20] In her design Miller multiplies the boat motif in a rhythmic dance of sails. Despite the strong surface patternization, the tonal range utilized in the sails and landscape elements serves to create a surprising sense of three-dimensional volume and deep space. The formal power of *Korean Junks at Sunset* is all the more evident when compared to *Inland Sea, Japan* (figure 76). Here the white of the sails and seagulls distracts from the harmony of the blues and grays comprising the water, earth and sky. *Inland Sea* offers a prosaic Orientalist scene where *Korean Junks* creates a poetic vision in which Oriental images are deployed.

**Figure 74**
*Ikkeisai Yoshiiku:*
*Makoto no*
*tsukihana no*
*sugata-e,*
late 19th century.
CATALOG 20

**Figure 76**
*Inland Sea, Japan,*
1928.
CATALOG 86

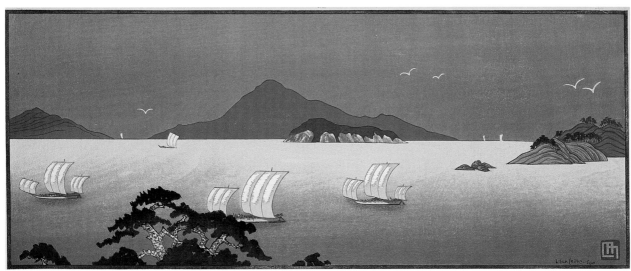

70

**Figure 75**
*Korean Junks at
Sunset,* diptych,
1928.
CATALOG 85

71

Miller's greatest prints are likely the two views of Mt. Fuji in *Moonlight on Fujiyama, Japan* (figure 77) and *Sunrise at Fujiyama, Japan* (figure 78). Along with *Korean Junks at Sunset* these were listed at $50 in 1929 and in 1941. The prints are meticulously made—a fact demonstrated by the existence of a trial print bearing extensive notes for color corrections. While the majesty of Mt. Fuji, the standard emblem of Japan, is undeniable, the prints seem more about the beauty of the mountain than about its role

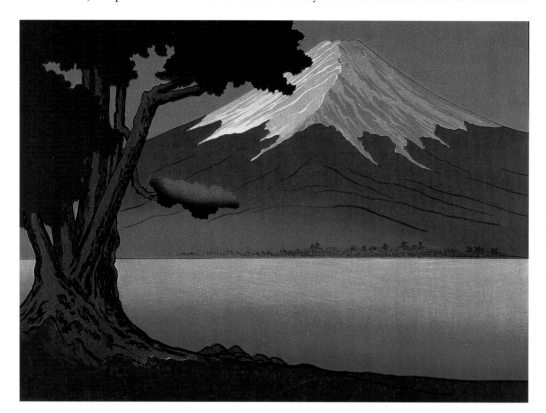

**Figure 77**
*Moonlight on
Fujiyama, Japan,*
1928.
CATALOG 87

**72**

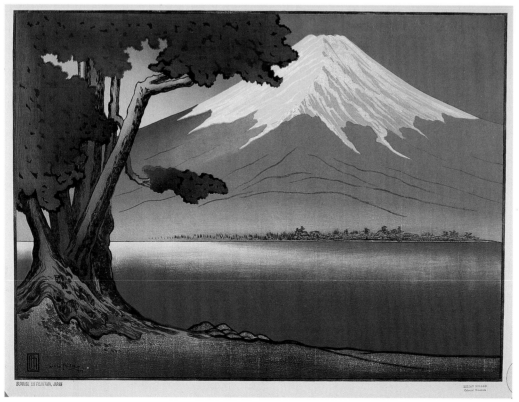

**Figure 78**
*Sunrise at
Fujiyama, Japan,*
1928.
CATALOG 88

**Figure 79**
*Moonlight on Mt. Fuji,* undated.
CATALOG 89

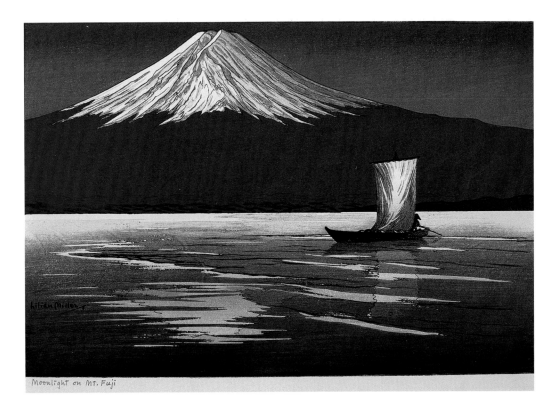

as a signifier for Japan. For instance, among the 14 prints of Mt. Fuji made by the strongly nationalistic Yoshida, no image includes any feature (other than wispy clouds) above the sacred peak. In these prints, by contrast, Fuji is overshadowed by the large foreground tree. In the *Moonlight* print Fuji's snow-capped crown glistens with luminescence, the sparkle all the greater for the dark surfaces around it. In the *Sunrise* print, the whole image radiates the first light of dawn which brings out the pastel hues of mountain, water and foliage. The textures of the prints, too subtle to be captured in photographs, are created by Miller's mix of vegetable, mineral and oil-based pigments. The presence of the artist's hand in the work—Miller's process more evident here than in most prints—complicates the Orientalism implicit in the scene. Nonetheless, the print is about the viewer's "esthetic delectation" of Japan, and thus Japan is associated exclusively with beauty.

## POLYCHROME VERSUS MONOCHROME

AFTER RETURNING TO JAPAN IN THE SUMMER OF 1930 Miller waited for several years before sending to Seoul for her print-making materials. In these years she devoted herself to painting watercolors of Kyoto and Nikkô, producing more than 100 pictures (see Appendix for works exhibited in 1933). When she retook possession of her printing tools by 1933 Miller may have used her old blocks to reprint the most successful earlier designs—one explanation for undated prints of the 1928 designs. Miller also created more than a dozen new works, about half of them undated but presumably done between 1933 and 1935. The prints of the early 1930s fall into two distinct types: those with overtly Orientalizing themes, vibrant polychromy and obvious commercial appeal; and, in sharp contrast, monochromatic prints with minimal narrative potential relative to their formal beauty.

In many images of the former type Miller adapts compositions from her more popular prints of 1928. *Moonlight on Mt. Fuji* (figure 79), for instance, slightly alters the mountain in *Moonlight on Fujiyama,* excises the tree but includes a sanpan on the glistening waters. A nocturne in blue and white, the print rivals the earlier work in

**73**

both printing technique and ethereal beauty. *Sanpans at Sunset, Japan* (figure 80) takes the subject and color scheme from *Korean Junks at Sunset*, eliminates the structure and the multiple boats but in their place adds two foreground lanterns and a pine tree. While still a dramatic design rendered with subtle gradations of gray which suggest atmospheric perspective, it falls short of the earlier print. Miller also made one more bonsai, *The Little White Plum Blossom* (figure 81). The print lacks the careful carving and printing of the

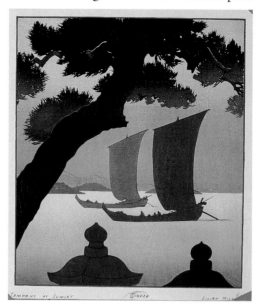

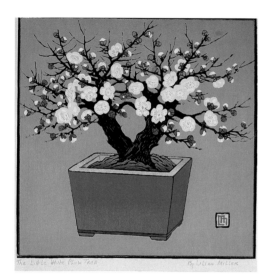

**Figure 80**
*Sanpans at Sunset, Japan*, 1934.
CATALOG 90

**Figure 81**
*The Little White Plum Blossom Tree*, undated.
CATALOG 91

**Figure 82**
*Rain in the Willows*, undated.
CATALOG 92

earlier *Japanese Dwarf Plum Tree* prints (figures 62 & 63), and substitutes a garish green for the black or gray backgrounds of the 1928 works. Major variations between prints in the rendering of the blue on the planter box suggest either haste in production, or the dissatisfied artist's experimentation. Far more successful is *Rain in the Willows* (figure 82), a creative adaptation of *Rain Blossoms, Japan* (figures 72 and 73). Although set at the same bridge, here the drooping willows block off all but one post. More critically, the mother and daughter in the foreground are rendered with naturalistic volume while only the figure in the middleground is depicted in the silhouette used to render the fore, middle and background figures in the somewhat awkward earlier print. The mystery of this ghostly person is compounded by the willows which envelop the figures, and by the child's pose of turning to look backward.

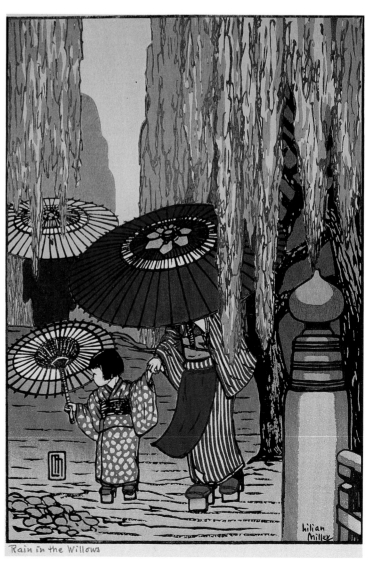

**Figure 83**
*Blue Hills and Crescent Moon,* 1934/1935.
CATALOG 93

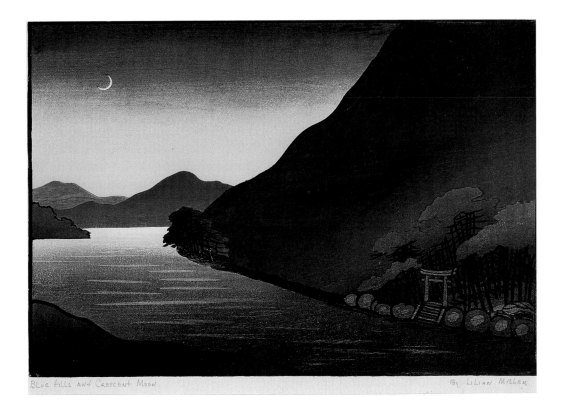

**Figure 84**
*Mountain Lake at Dawn,* undated.
CATALOG 94

Miller also created several stylistic and thematic variations of her 1928 landscape *"The Crescent Moon Rides Low," Korea* (figure 56). *Blue Hills and Crescent Moon* (figure 83) adapts the earlier print by flipping the foreground hillock from right to left, expanding the river to fill the center of the picture, dramatically increasing the size of the right-hand mountain, and sliding the crescent moon to the left. The slumbering village in the earlier print is replaced by a shrine gate. *Mountain Lake at Dawn* (figure 84) focuses on the subject of a watercourse and hillside, while *Moonrise Over a Kyoto Hillside* (figure 85) presents the extremely simple image of a moon emerging from clouds. The saturated colors of most 1928 prints are absent as Miller instead emphasizes the effects of carved lines and shapes. In *Pagoda at Dusk, Kyoto* (figure 86) Miller does away with all color except for the red railing of the two-story pagoda (echoed in her seal). In this nocturne in shades of gray, the subtlety of the tones minimizes the contrast between the rectilinear volume of the pagoda and the flat patterning of the landscape. The print may have been successful because Miller also printed a slightly

**Figure 85**
*Moonrise Over a Kyoto Hillside,* 1934.
CATALOG 95

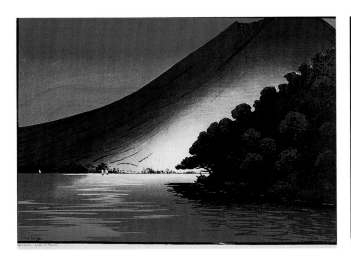

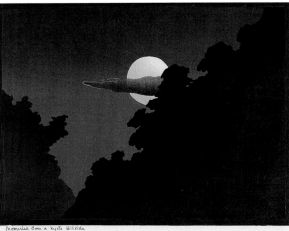

larger version (figure 87) with darker tones. Comparison with a greeting card of a similar subject (figure 88), presumably from about the same time, reveals Miller's conscious effort to distance her serious work from overtly picturesque scenes of the Orient. Perhaps her dedication to delicate and impressionistic watercolors led Miller to pursue in prints those formal effects particular to the woodblock medium. As with the *Diamond Mountains* series (figures 49-54) and *Hongkong Junk* (figure 48), these prints evince a *sôsaku-hanga* sensibility but without the self-conscious crudeness.

Miller's propensity to structure her early 1930s prints as studies in blue and gray—evident in these prints as well as in *Inland Sea, Japan* (figure 76) and *Moonlight on Mt. Fuji* (figure 79)—is most pronounced in three prints based on columnar motifs. Beginning in the 1930s Miller seems to have become fascinated with huge tree trunks—posing before a tree in a 1931 photograph (figure 15), taking numerous photos of them upon her move to California, and featuring them in her paintings (figure 23)—to an extent that almost begs Freudian analysis. Although the tree trunk motif appears in earlier works, including *In a Korean Palace Garden* (figure 8), *Orange-Sailed Junk of the Han* (figure 36) and *Nikko Gateway* (figure 58), the dark tree trunks of later prints have an enigmatic presence. In *Drum Tower, Nikko, Japan* (figure 89) Miller uses the inky tree in the foreground—the striations of the bark barely visible and its volume thus denied—as a foil for the multi-hued complexity and three-dimensionality of the ornate drum-tower. The radical formal disparity between the splendor of the man-made architecture and the natural majesty of the tree is lent an aura of mystery by the unnatural blue-white-blue layering of the sky. In *Festival of Lanterns, Nara* (figure 90), glowing lanterns are dwarfed by a massive tree, its luminous trunk set off against the mat-finish pastel of the boughs. Comparing this work with a small greeting card print (figure 91) presumably from the same period, Miller's deployment of the abstracting tree trunk seems a deliberate effort to negate or at least complicate the conventional Oriental charm suggested by lanterns. The same effect is witnessed in *Nanzenji by Moonlight* (figure 92) where the artist provides a partial view of the temple wall, foliage and (barely visible) hillside from within the great gate—the massive columns of the structure obscuring much of the ostensible focus of the scene. The Japanese temple seems merely the means for Miller's play of tones, shapes and textures.

**Figure 86**
*Pagoda at Dusk, Kyoto (small),* 1934.
CATALOG 96

**Figure 87**
*Pagoda at Dusk (large),* undated.
CATALOG 97

**Figure 88**
*Torii and Lanterns,* undated card.
CATALOG 36 C

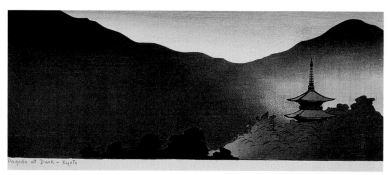

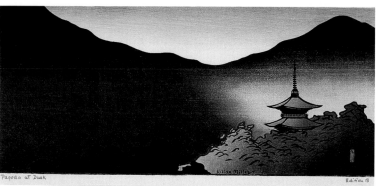

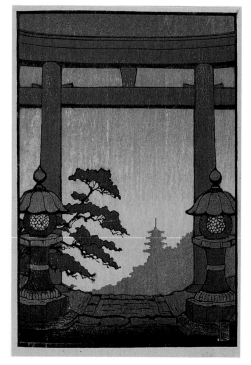

**Figure 89**
*Drum Tower,*
*Nikko Japan,*
undated.
CATALOG 98

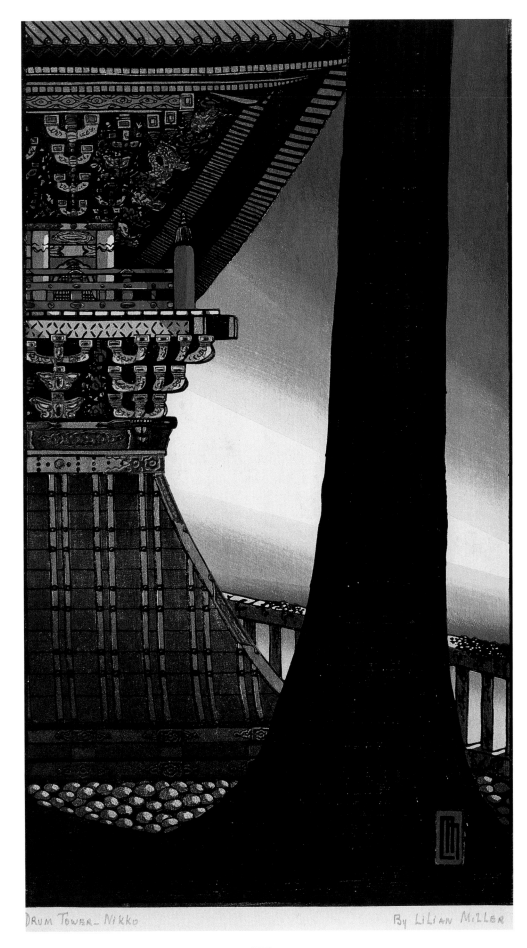

Drum Tower — Nikko                    By Lilian Miller

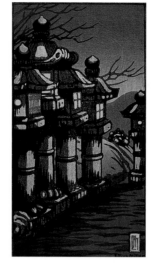

**Figure 91**
*Lanterns at Night,*
undated card.
CATALOG 36 D

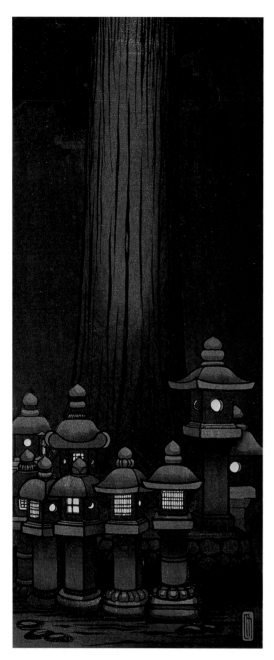

**Figure 90**
*Festival of Lanterns,*
*Nara,* undated
(ca. 1934).
CATALOG 99

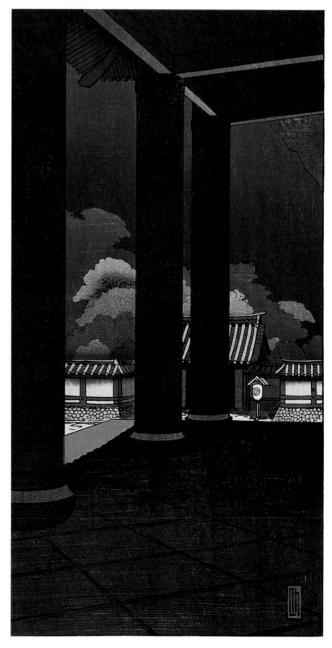

**Figure 92**
*Nanzenji by*
*Moonlight,* 1934.
CATALOG 100

79

**Figure 93**

*Snow on Temple Roofs (blue sky),* undated (ca. 1934). CATALOG 101

**Figure 94**

*Snow on Temple Roofs (gray sky),* undated (ca. 1934). CATALOG 102

The most striking aspect of Miller's late print corpus is the jarring discontinuity between these subtle and creative works which subvert picturesqueness and those works which traffic in the familiar subjects and styles of Orientalist art. In *Snow on Temple Roofs,* printed with a blue or a gray sky (figures 93 & 94), Miller bases her composition on the simple contrast between the large v-shaped composition of the snow bank and the inverted "v" of the ornate temple gable. The image recalls the composition, coloration and subject of Hiroshige's famous *Evening Snow at Kanbara* from his *53 Stages of the Tôkaidô. Torii Leading to Fox Shrine* (figure 95) presents an even more exotic scene, with a simple composition based on the view through the avenue of *torii* "complicated" by the gratuitous pine at foreground right and the awkward tree trunk at left. The tiny figure in the far distance provides the only clever and subtle note. Relative to the rich over-printing of colors in the "blue prints" and in most works from 1928, here the colors are as flat and perfunctory as the carving. Made when Miller was for the first time wholly dependent on the sale of art for her financial support, some of these works may well have been manufactured quickly in order to present her dealers with salable products. There is perhaps no other satisfactory explanation for such pedestrian efforts as *Lantern on a*

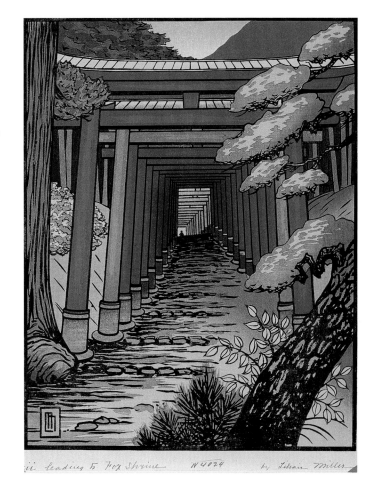

**Figure 95**

*Torii Leading to Fox Shrine,* undated. CATALOG 103

*Hill, Nikko, Autumn* (figure 96) and *Lantern on a Hill, Nikko, Spring* (figure 97).

Three final prints clarify the contrast between Miller's two approaches to print subject and style, a difference which suggests tension between her overtly commercial art and her more daring formal explorations. *A Kyoto Garden at Azalea Time* (figure 98) and the pair *East Mountain, Kyoto, Sunrise* and *East Mountain, Kyoto, Dusk* (figures 99 & 100) represent the two poles of Miller's work. *A Kyoto Garden* embodies the type of pretty garden scene which Miller featured in her highly salable watercolors. The print, despite the modest abstraction of the various forms, presents an easily readable space—and a place which is clearly part of the beautiful Orient. The *East Mountain* prints, in contrast, include two lanterns which establish the Oriental setting, but at heart are about the disjunctive shapes, textures and space created by the stencil-thin foreground tree, the ambiguously situated lanterns, and the floating form of the mountain. Although Miller does not divorce herself from the Oriental emblems central to her artistic and personal identities, these works bear little relation to the sentimental vision of Japan presented in *A Kyoto Garden*.

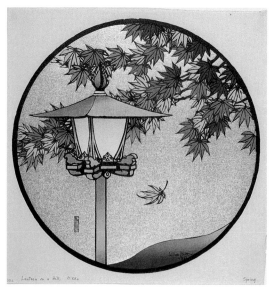

80

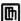

**Figure 96**
*Lantern on a Hill, Nikko, Autumn,* 1934.
CATALOG 104

**Figure 97**
*Lantern on a Hill, Nikko, Spring,* 1934.
CATALOG 105

**Figure 98**
*A Kyoto Garden at Azalea Time,* 1935.
CATALOG 106

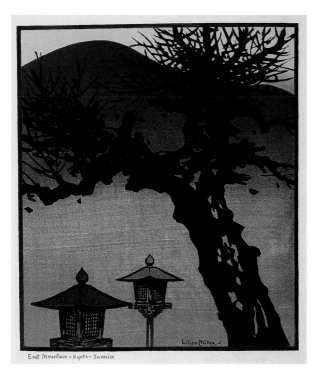

## FADE TO BLACK

**Figure 99**
*East Mountain,
Kyoto, Sunrise,*
undated.
CATALOG 107

**Figure 100**
*East Mountain,
Kyoto, Dusk,*
undated.
CATALOG 108

**W**ITH HER MOVE TO HONOLULU EARLY IN 1936, Miller ended one aspect of her career and began another by again shifting the style of her art and the dynamic of her Orientalism. After a major cancer operation, Miller likely lacked the strength required to make woodblocks. Moreover, the uneven level of her later work, and apparent lack of significant commercial success, may also have contributed to Miller's abandonment of woodblock prints. Finally, after 15 years and more than 60 prints, Miller may well have desired to explore new media. In Hawai'i Miller returned to ink painting—the style in which she had begun her training as a child. While many paintings from 1936-38 are of scenes in the Hawaiian Islands or of non-specific landscape scenes such as waterfalls (figure 18), Miller did not abandon Oriental subjects. However, with the exception of a few such retrospective works as *Landscape in Japan* (figure 101), she largely confined herself to such generic subjects as bamboo or pines, choosing the brush conventions appropriate to the subject. In *Mist in the Pines* (figure 102), for instance, Miller utilizes the tip of her brush

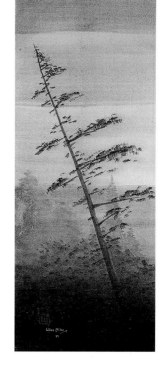

**81**

**Figure 101**
*Landscape in
Japan,* undated
(ca. 1937), ink
on paper.
CATALOG 29

**Figure 102**
*Mist in the Pines,*
1937, ink on paper.
CATALOG 30

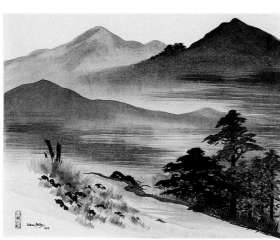

to suggest the texture of the pine branches seen through the fog. After her move to San Francisco at the end of 1938, Miller continued to paint outdoor scenes: her waterfalls and redwoods (figure 23) rendering those aspects of California topography and flora which parallel her native Japan. Although Miller was fairly skilled in naturalistic polychrome painting—as demonstrated by this detailed color sketch of moths (figure 103)—she largely confined her public art to ink monochrome images of subjects with at least faintly Oriental overtones.

Miller also retained her connection to printing, with its inherent commerciality, but in Honolulu shifted to lithographs and lithotints. Together with printers at the *Honolulu Star-Bulletin,* Miller produced a new mechanical print medium—the lithotint, which, as one writer described, was appropriately developed in Hawai'i "crossroads of the Pacific, since [the lithotint] is a combination of the techniques of the Orient and Occident."[21] To create *Spray of Bamboo* (figure 20), a 1938 gift for associate members of the Honolulu Print Makers, Miller used a three-inch "Oriental brush" and western touche (liquid lithographic ink) to paint a design of bamboo on to a zinc plate. The newspaper printers then carefully printed 100 sheets from the plate, preserving the tonal gradations of the original. During the trial processes, the printers produced *Pines of the Heights*

**Figure 103**
*Moths,* 1941, color on paper.
CATALOG 36 E

**Figure 104**
*Study in Black and Silver,* 1938.
CATALOG 110

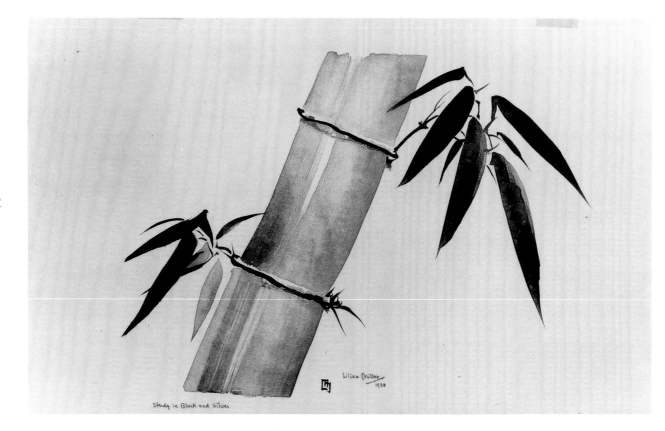

Study in Black and Silver

(figure 21). Miller turned several more of her bamboo paintings into prints, including *Study in Black and Silver* (figure 104) and *Black Bamboo* (figure 105). These variations on bamboo link Miller's initial study brush drawing with the printing medium in which she made her career. Because they lack the narrative quality of her early prints or the exotic scenery of her later woodblock images, the monochrome bamboo prints constitute a continuing evolution toward greater abstraction and expressivity in Miller's work. Despite significant differences from her color prints, these works utilized Miller's training in Japanese art even as they furthered her image and commercial viability as a "Japanese artist" in America. Miller no longer represents the Orient through her print subjects, now—in the words of a 1940 newspaper headline—this Western "Painter Beats Japanese At Their Own Art."[22]

## REFOCUS

**Figure 105**
*Black Bamboo,*
1938.
CATALOG 111

MILLER'S ART WAS BROUGHT TO A HALT first by the Japanese attack on Pearl Harbor, an event so troubling to the artist that she gave up painting and considered the destruction of her early "charming" prints; then in 1943 the artist's hand was stilled by death. While scholars have resurrected the careers of other Orientalist print-makers—Hyde, Lum, Keith and Jacoulet each receiving at least one study—Miller has languished.

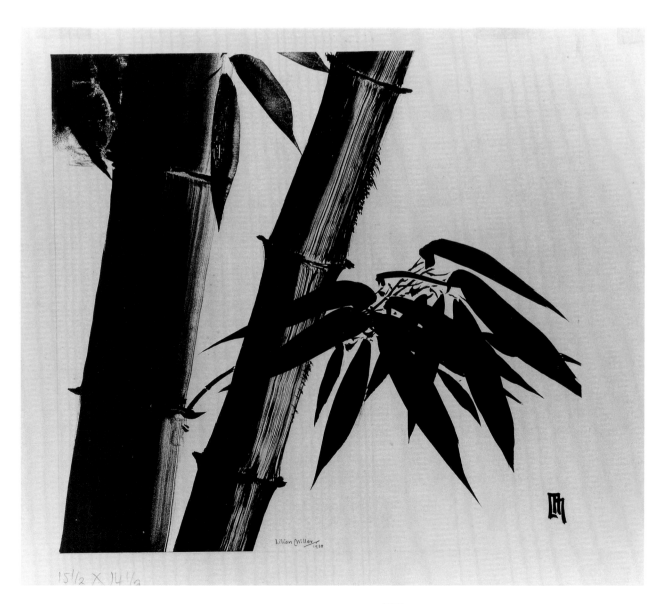

83

Though the greater stylistic and thematic range of her art together with the richness of her biography suggest that she may be the most compelling of these artists, these very qualities may have led to her marginalization. Miller, in the details of her life and the evidence of her production, stands outside the more overt Orientalism of these artists— a quality recognized implicitly by the biographers of Hyde, Lum, Keith and Jacoulet even though they do not use the term. In sum, relative to her contemporaries, Miller's art is too variable, evolving from quaint figures to landscapes to bamboo studies, and her relation to the Orient is too dynamic.

In addition, Miller, and other Western print-designers in Japan, have been written out of academic art history because they are fundamentally at odds with modernist ideas of art—a fate similar to that of Miller's Vassar classmate and fellow poet Edna St. Vincent Millay. First, in that much of her art is "sentimental," stirring emotion by evoking absence and loss, it has been ignored by masculinist criticism which reads sentimentality as the indulgent pathos of feminine production appropriate perhaps for display at home but not for the public realms of the museum or serious art historical discourse. Second, because Miller's corpus entails substantial stylistic change and thematic ambivalence, satisfying demands for the familiar and for the unexpected, she also offends the modernist sensibility which frowns upon stylistic uncertainty or vacillation. Finally, Miller was trapped in the paradox of female success: the more she was acknowledged within the community of women who wrote about and bought her art, the less she was considered serious in the world of "high art." This criticism of Miller ignores the "difference" of women who produce for a bourgeois audience and seek not the alienation or estrangement of the viewer from the art work, but the building of a community based on shared visions.[23] For Miller, this construction of community took place through Orientalism.

In terms of her relations to the Orient and Orientalism, Miller's dual constituencies, including primarily female consumers desirous of sentimental views of the timeless East and critics interested in avant-garde formal explorations, may largely explain the artistic origins of the ambivalence which led Miller to challenge the form and content of her work even as she constantly reiterated her status as an inside interpreter of the Orient. Homi Bhabha suggests that "productive ambivalence" is "one of the most significant discursive and psychical strategies of discriminatory power." This process of "subjectification" takes place through the creation or deployment of stereotypes based on a relation with "Otherness" which is "at once an object of desire and derision, an articulation of difference contained within the fantasy of origin and identity."[24] Miller's "productive ambivalence" may well be partially based on exactly this dynamic in which it is central to her identity to be part of the Orient, yet that same identity is also formed by a control of the Orient which establishes her superior status in the East and her professional success in the West. Yet Miller was unlike virtually all other female East Asian Orientalist artists in that her view of the Orient was not based on exteriority to it, but, because of her birth and training in Japan, was founded on a constantly negotiated status of both exteriority and interiority. However much the will to "discriminatory power" may have motivated her, for Miller—the embodiment of difference—her public and personal identities were also defined by an ambivalence that may at times be just the ambivalence of an artist who lived on the uncertain edge of two cultures, at constant risk of falling "in the gulf between."

**84**

**Detail**
*Black Bamboo*

## NOTES

1. This thumb-nail definition is condensed from Edward Said, *Orientalism* (New York: Random House, 1978). For a critique of the book, see "On *Orientalism*" in James Clifford, *The Predicament of Culture: Twentieth-Century Ethnography, Literature and Art* (London and Cambridge, MA.: Harvard University Press, 1988).

2. Linda Nochlin, "The Imaginary Orient," *Art in America* (May 1983) pp. 119-31, 186-91.

3. Linda Nochlin, "Women, Art, and Power," in *Women, Art, and Power, and Other Essays* (New York: Harper and Row, 1988) p. 26.

4. Reina Lewis, *Gendering Orientalism: Race, Femininity and Representation* (London: Routledge, 1996).

5. The image seems to have been accompanied at times by a single line of text "The spirit of the artist lives in the tip of the brush," although the August 12, 1923 *San Francisco Chronicle* article on Miller begins with her poem: "In a gray mist, beneath the morning moon,/I saw the slender bamboo at my gate/Half hide her face behind a glistening sleeve/Of freshly fallen snow."

6. John Stewart Happer, "Art and Crafts, Modern Wood Engraving and Colour Prints," *The Far East* 22:5 (May 28, 1921), p. 168.

7. "American Girl Depicts Spirit of East Through Color Prints," *The Japan Advertiser*, January 28, 1922, p. 2.

8. Nadia Lavrova, "Vassar Girl Portrays Hidden Beauty of Korea In Color," *San Francisco Chronicle*, August 12, 1923, p. 3.

9. The print is found in Tim Mason and Lynn Mason, *Helen Hyde* (Washington and London: Smithsonian Institution Press, 1991) p. 71. Lum's print is published in Mary Evans O'Keefe Gravalos and Carol Pulin, *Bertha Lum* (Washington and London: Smithsonian Institution Press, 1991), p. 39. The fact that Miller's printer Nishimura Kumakichi II also worked for Lum may further explain the connection.

10. An alternate text for the print, indicating that Miller may well have produced multiple texts for each print, reads: "Laden with ivory bags of rice, these orange-sailed junks sail dreamily down the placid reaches of the Han, looking in the distance like scarlet peonies floating on the green bosom of the river; and when perhaps glimpsed through the branches of a stately pine, one can well understand the reason for the name written in gilt characters above a little shrine on one back, where it sits on a hilltop overlooking the distant hills:— 'Temple of the Flowery Stream.'"

11. It is worth noting that in the numerous figure paintings and prints of Helen Hyde from roughly 1900 to 1915, one of the very few images in which the viewer's gaze is met by a figure occurs in *From The Rice Field* of 1901 in which a mother, with a baby on her back and a child walking at her feet, looks directly at the viewer (Mason and Mason, *Helen Hyde,* p. 36). When the women in Bertha Lum's prints look toward the viewer it is always with the downcast eyes of the coquette. Elizabeth Keith often directs the eyes of the figures in her portraits to the viewer, yet these gazes are somehow disengaged and possess little sense of challenge. For a discussion of the sexual politics of "the gaze," see Griselda Pollock, *Vision and Difference: Femininity, Feminism, and Histories of Art* (London: Routledge, 1987), especially "Women And the Gaze," pp. 85-90.

12. Stewart J. Teaze and James D. Tobin, undated manuscript for "Modern Japanese Wood-block Prints Shin-hanga, Traditional Print Makers," unpaginated.

13. Harriet Miller Cooper, "Japanese Woodblock Prints of Lilian Miller," January 7, 1930 letter sent to Miss Olmstead of the Syracuse Museum of Fine Arts," p. 2.

14. For a review of the *shin-hanga* movement, see Kendall Brown and Hollis Goodall-Cristante, *Shin-hanga: New Prints in Modern Japan* (Los Angeles: Los Angeles County Museum of Art, 1996). For a review of *sōsaku-hanga,* see Helen Merritt, *Modern Japanese Woodblock Prints, The Early Years* (Honolulu: University of Hawaii Press, 1990).

15. "Color Prints of Lilian Miller At Beaux Arts," *San Francisco Chronicle,* April 12, 1931, p. 10.

16. Isabella Bird Bishop, *Korea, And Her Neighbors* (Chicago: Student Missionary Campaign Library, 1897) p. 98.

17. From "Nikko," *Grass Blades From A Cinnamon Garden*, p. 76.

18. Joan S. Grigsby, "Weather Moods," *Asia* XXXI:11 (November 1931), p.724. Miller's print *Rain Blossoms* is illustrated by the poem "Rain In Tokyo."

19. "This Japanese Artist Is An American," *Art Digest*, Mid-October 1929, p. 22. The print is also published to accompany Grigsby's poem "Rain In Tokyo," in Joan S. Grigsby, "Weather Moods," *Asia* XXXI:2 (November 1921) p. 724.

20. The series is published in part in Penelope Mason, *History of Japanese Art* (New York: Prentice Hall and Harry N. Abrams, 1993) p. 351, and in full in *The Complete Woodblock Prints of Yoshida Hiroshi* (Tokyo: Abe Publishing, 1987), pp. 57-60.

21. Alice Poole, "New Print Medium, Lithotint, Is Perfected in Honolulu," *Honolulu Star-Bulletin*, November 3, 1938. The article describes the process of making the lithotint.

22. The "headline" is one of several used for "American Woman Becomes Renowned Oriental Artist" *Pasadena Post*, April 7, 1940, p. 1.

23. For discussions of these criticisms relative to Millay, see Jo Ellen Green Kaiser, "Displaced Modernism, Millay and the Triumph of Sentimentality," in Diane P. Freedman, *Millay at 100, A Critical Reappraisal* (Carbondale and Edwardsville: University of Southern Illinois Press, 1995); and Gilbert Allen, "Millay and Modernism," and Suzanne Clark, The Unwarranted Discourse: Sentimental Community, Modernist Women, and the Case of Millay," both in William B. Thesing, ed., *Critical Essays on Edna St. Vincent Millay* (New York: G. K. Hall, 1993).

24. Homi Bhabha, *The Location of Culture* (London: Routledge, 1993) p. 66.

**Detail**
*Pagoda at Dusk,
Kyoto*

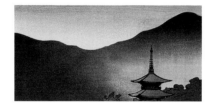

# APPENDIX
## LILIAN MILLER WATERCOLORS
### *Exhibited December 13-17, 1933 at Shiseidô Gallery, Tokyo (prices in yen)*

*Branch of Red Berries* (100)
*Mountain Slope Under Snow, Nikko* (80)
*Mountain Ravine Under Snow, Nikko* (80)
*Fuji-san* (not for sale)
*Sunset in Kyoto* (table screen) (80)
*Mt. Omonago in Winter, Nikko* (75)
*Cryptomeria and Stone Buddha, Nikko* (75)
*Nishi Hongwanji by Moonlight, Nikko* (75)
*Ohara Thatched Roofs by April Moonlight,
    Kyoto* (75)
*Noon on the High Seas* (70)
*Iris* (70)
*Camellias and Iris in Heian Gardens, Kyoto* (65)
*The Little Shrine in the Woods, Kyoto* (65)
*Narcissus and Plum* (65)
*A Mountain Ridge, Gray Day, Nikko* (65)
*The Silver Pine, Ohara, Kyoto* (not for sale)
*Blue Hills through Bamboo, Ohara, Kyoto* (60)
*Wall at Pyong-yang (Heijo), Korea* (60)
*Entrance to the Royal Tombs, Seoul (Keijo),
    Korea* (60)
*Stone Lanterns, Sakamoto* (60)
*Maples in a Nikko Garden* (50)
*Nikko Garden Late in Autumn* (50)
*Nikko Waterfall with Maples* (50)
*The Yellow Maple and the Red, Nikko* (50)
*Somentake, Nikko* (50)
*Waterfall* (50)
*Cryptomeria Grove, Moonlight* (50)
*Chuzenji Hilltop, Moonlight* (50)
*Autumn in a Kyoto Garden* (50)
*Gate at Sanzen'in, Kyoto, in Azalea Time* (50)
*Springtime in Kyoto* (50)
*Kyoto Temple Gateway* (50)
*Kyoto Garden with Wild Azaleas* (50)
*Plum Garden in Blue Pot* (50)
*Mandryo Berries in Pot* (50)
*The Sacred Cryptomeria, Kurayama, Kyoto* (50)
*Waterfall in the Kyoto Hills* (50)
*Sakamoto Moss Garden, Entrance* (50)
*Kyoto Residence Gateway* (50)
*The Poet's House in the Woods, Kyoto* (50)
*Zinnias* (50)
*Snowy Hillside, Kyoto* (50)
*Morning Sea* (50)
*Study in Slopes* (50)
*Pine and Stone Lantern* (40)
*Moonlight in the Gorge* (40)

*Antique Brass Candlestick* (40)
*Stone Lantern and Cryptomeria, Autumn Study* (40)
*The Water Lily* (40)
*Oak Leaves (40)*
*Mountain Shrine, Kyoto* (40)
*Gate in Heian Garden, Kyoto, in Iris Season* (40)
*Anrakuji Garden Gate, Kyoto* (40)
*Kyoto Mountain Path* (40)
*Rinnoji Garden, Nikko, Autumn* (40)
*Inari Canyon, Winter, Nikko* (40)
*Cherry Blossoms of Yoshino* (30)
*The Round Window* (30)
*Hillside Azaleas, Kyoto* (30)
*Hunting House* (30)
*The Orange Candle* (30)
*In The Park* (30)
*Looking Out to the Sea* (30)
*Wild Pinks and Suzuran* (30)
*The Bamboo Vase* (30)
*The Garden Gate* (25)
*Pine Cones* (25)
*Chrysanthemum Study* (25)
*Willow and Silver Fish Jumping* (25)
*Chochin* (25)
*Moon Over Hills* (25)
*The Summer House, Heian Garden, Kyoto* (25)
*Temple Gate by Moonlight* (25)
*Tea Ceremony Garden, April Moonlight* (25)
*The Scarlet Male Tree* (25)
*Korean Windjammer* (25)
*Autumn Branch* (25)
*The Harbor by Moonlight* (25)
*Stone Lantern, Gray Dusk* (25)
*Snow in Nanzenji, Kyoto* (25)
*Sunlight and Shadow on the Kyoto Hills* (25)
*Cryptomeria and Mountain Stream*
    (Loaned by Mrs. Joseph C. Grew)
*Nirvana* (Loaned by
    Mr. and Mrs. S. Walter Washington)
*Study of a Hillside* (Loaned by
    Mr. and Mrs. S. Walter Washington)
*Water Lilies and Reed Grass* (Loaned by
    Mrs. Stephen Von Rennselaer Crosby)

(Also included in the show was the ink mono-
chrome painting *Windblown Bamboo Spray* done
in 1919 to secure Miller's return to Shimada
Bokusen's atelier.)

**87**

# EXHIBITION CHECKLIST (CATALOG)

### NOTE TO THE READER

Unless otherwise noted, all art works are by Lilian Miller and are color woodblock prints on paper. Titles which appear on the print (or some copy of it) are given in italics; if the title is interpreted from the work, it appears in regular typeface. All text written on the print image or margin—including signature, seals and title—is given in italics. Dimensions are given with height followed by width. The collection is followed by the figure number indicating order of illustration in the text.

### I. INTRODUCTION.

*Photos of Lilian Miller:*

1. Family portrait (Ransford Miller, Lily Miller, Harriet [on lap], Lilian), November 1899; by K. Ogawa, Tokyo; Amelia C. Dupin. FIGURE 1.

2. On back of Japanese maid, ca. 1896; by Genrokukan Photographic Studio, Tokyo; Amelia C. Dupin. FIGURE 3.

3. Profile portrait, ca. 1910; signed: *Your 'boy' Jack*; Amelia C. Dupin. FIGURE 4.

4. Highschool portrait, ca. 1913; Special Collection, Vassar College. FIGURE 5.

5. Printmaking, ca. 1930; Huntington Library. FIGURE 13.

6. In kimono at Nicholson Gallery, April 1930; by Dickson & Thurber, Pasadena; Special Collection of Vassar College. FIGURE 14.

7. By tree in Nara, dated on verso *May 1931*; Huntington Library. FIGURE 15.

8. Shiseidô Gallery Exhibition, Tokyo, 1933; Special Collections, Vassar College. FIGURE 16.

9. Sketching in Hawai'i, ca. 1936; Amelia C. Dupin. FIGURE 18.

10. Christmas portrait, 1938; signed: *For Hal & Jim, Xmas, 1938, Jack*; by Murle Ogden, Honolulu; Amelia C. Dupin. FIGURE 22.

11. In front of painting, ca. 1940; Lillian Miller Collection, Scripps College. FIGURE 23.

### II. METHODS & MATERIALS.

12. Chisel, *baren* and rest, 4 flat brushes with LMM seal, 2 ceramic pestles; Lilian Miller Collection, Scripps College.

13. Four seals; Lilian Miller Collection, Scripps College.

14. 15 tubes of Windsor & Newton water color pigment, 13 tubes of Lefranc water color pigment, 5 tubes of Devoe & Reynolds water color pigment 1 tube of Pelikan-Farbie water color pigment, 23 vials of powder pigments from Nakamura Kaisendô Tokyo, 2 vials (cobalt blue and chrome orange) from J. I. Bumpôdô, Tokyo, 1 vial of pigment ore powder from Saibidô, 4 small unlabeled vials of powder pigment; 1 dish of peacock green pigment, 1 dish of lemon yellow pigment, 1 envelope of apple green powder pigment in Nakamura Kaisendô envelope, 1 envelope of red powder pigment in Miyako Hotel envelope; Lilian Miller Collection, Scripps College.

15. Key block for *Japanese Dwarf Plum Tree*, reverse key block (background block) for *Japanese Dwarf Plum Tree*, 1928; (each block 40.2 x 26.7 cm); Lilian Miller Collection, Scripps College.

16. 5 stages of Japanese *Japanese Dwarf Plum Tree* and variation copy of *Japanese Dwarf Plum Tree*, seal: *LMM*, signed: *Lilian Miller*, 1928; (image 36 x 24. cm); Lilian Miller Collection, Denison Library, Scripps College.

17. 13 stages of *Hongkong Junk, Noonday* and finished print *Hongkong Junk, Noonday*; signed: *Lilian Miller*, margin: handwritten *"Hongkong Junk," Noonday*, (image 35.5 x 24.3 cm, sheet 39.4 x 26. 2 cm), Lilian Miller Collection, Denison Library, Scripps College.

18. Trial proof with artist's corrections for *MT. FUJI BY MOONLIGHT*; (image 36.4 x 51.5 cm, sheet 42.5 x 54 cm); Lilian Miller Collection, Denison Library, Scripps College.

### III. LILIAN MILLER'S COLLECTION OF JAPANESE BOOKS AND ALBUMS.

19. Kamisaka Sekka (1866-1942): *Momoyogusa 2*, published Kyoto: Unsôdô, 1910; title calligraphy by Tomioka Tessai (1836-1924); (open 30.0 x 44.7 cm); Lilian Miller Collection, Denison Library, Scripps College. FIGURE 70.

20. Ikkeisai Yoshiiku: *Makoto no tsukihana no sugata-e*, late 19th century; (open 35.5 x 46.7 cm); Lilian Miller Collection, Denison Library, Scripps College. FIGURE 74.

21. Anon, floral design album, ca. 1910; (open 27.4 x 38 cm); Lilian Miller Collection, Denison Library, Scripps College. FIGURE 68.

22. Tsuda Seifû (1880-19??): *Ao momiji; published Kyoto: Honda Unkindô*, 1902; (single page 24.5 x 36.5 cm); Lilian Miller Collection, Denison Library, Scripps College.

23. Tawaraya Sôtatsu: wave book, published Kyoto: Unsôdô, 1910; title by Tomioka Tessai (1836-1924) (single page 38.3 x 26.8 cm); Lilian Miller Collection, Denison Library, Scripps College.

24. Kano school painting album, ca. 19th century; (open 36.7 x 57.5 cm); Lilian Miller Collection, Denison Library, Scripps College.

IV. **PAINTINGS.**

25. Album of 4 Flower Paintings, ink and color on paper, 1909; signed: *Gyokka joshi*, seal: (unknown), first page signed: LM Miller; (includes certificate with art name *Gyokka* [Jewel Flower] bestowed by Shimada Bokusen March 1909); (single page 20.5 x 31.2 cm); Amelia C. Dupin. FIGURE 2.

26. *In a Korean Palace Garden*, 1920, hanging scroll, ink on silk; signed: *LM Miller, Hokubeijin Gyokka jo*, seals: *Hokubei gyokka, LMM*; (image 197.5 x 82.5 cm; mounted 332.5 x 1000.3 cm); Lilian Miller Collection, Scripps College. FIGURE 8.

27. *Mountain Path and Azaleas, Nikko*, 1935; watercolor on paper; signed: *Jack (?) Miller, 1935*; (round image 30 x 30 cm, mounted 39 x 38 cm); Amelia C. Dupin. FIGURE 16.

28. Landscape with Waterfall, 1937, ink on paper; signed: *Lilian Miller, 1937*, seals: *LMM, Gyokka*; (sheet 50.5 x 37.3 cm); Private Collection. FIGURE 17.

29. Landscape in Japan, ca. 1937, ink on paper; (image 31.6 x 40.8 cm); Honolulu Academy of Arts, Gift of Edith G. Manuel, 1943 (12,022). FIGURE 101.

30. *Mist in the Pines*, 1937, ink on paper; signature: *Lilian Miller, 1937*, seals: *Gyokka, LMM*; (sheet 51 x 21 cm); (attached to original mounting, paper reading: *All best wishes for Ann Runell, Lilian Miller, Nov. 25th 1939*); Private Collection. FIGURE 102.

31. Redwoods, 1939, ink & color on paper, signed: *Lilian Miller, 1939*, seals: *unknown, Hokubei gyokka*; (84.5 x 59 cm); Nabil Sejaan. FIGURE 22.

VI. **MISCELLANEOUS DRAWINGS, PAINTINGS AND PRINTS.**

32. Illustrated program for *A Midsummer Night's Dream*, 1914; (open 18.8 x 25.4 cm); Special Collections, Vassar College. FIGURE 6.

33. *In a Korean Garden*, graphite on paper, ca. 1920; (18.8 x 13.4 cm); Special Collections, Vassar College. FIGURE 7.

34. Woman Under Umbrella, ink on paper, ca. 1920; (sheet 26. 5 x 12 cm); Amelia C. Dupin. FIGURE 32.

35. Christmas and New Year's cards; all Amelia C. Dupin. FIGURES 9 a-h.

   (a) *An Orange-Sailed Korean Junk*, undated; seal: *LMM*; (sheet 18.5 x 7 cm).

   (b) Korean Man on Donkey (1923), seal: *LMM*; (sheet 22 x 11.4 cm).

   (c) Korean Man Smoking Pipe, undated; seal: *LMM*; (sheet 12.5 x 8 cm).

   (d) *Korean Girl with a Green Coat*, undated; rectangular seal: *LMM*; (sheet 17.6 x 6.8 cm).

   (e) Korean Boy Holds Rice Bowl, undated; (*"A NEW YEAR'S WISH FROM THE ORIENT. may your happiness be as overflowing during the NEW YEAR as this offering bowl of rice"*), seal: *LMM*; (sheet 20 x 10 cm).

   (f) Korean Spirit Posts, undated; rectangular box seal: *LMM*; (sheet 11.6 x 13.2 cm).

   (g) Korean Woman Walking in Snow, undated; rectangular box seal: *LMM*; (sheet 10.6 x 11.7 cm).

   (h) "The Crescent Moon Rides Low" Korea, undated; seal: *LMM*; (sheet: 8.5 x 13.7 cm).

36. Album of cards; all Phillips Library. FIGURES 25 a & b.

   (a) Camellia and Pine on Table, (*Christmas Greetings Elizabeth N. Grandy*), undated; rectangular box seal: *LMM*, signed on margin: *Lilian Miller*, (14.7 x 16.4 cm).

89

(b) Korean Junk, *(variation copy)*, undated; rectangular box seal: *LMM*, (14.7 x 16.4 cm).

(c) Torii and Lanterns, undated; rectangular box seal: *LMM*, (sheet 16.8 x 11.5 cm). FIGURE 88.

(d) Lanterns at Night, undated; rectangular box seal: *LMM*, signed: *Lilian Miller*; (18.6 x 13.4 cm). FIGURE 91.

(e) Moths, 1941, ink and color on paper; painted rectangular seal *LMM*; (18.6 x 13.4 cm). FIGURE 103.

**VI. BOOK ILLUSTRATIONS.**

37. *Grass Blades from a Cinnamon Garden*, Tokyo: The Japan Advertiser Press, 1927, (open 23.0 x 30.0 cm); Lilian Miller Collection, Denison Library, Scripps College.

38. Hand painted dedication page of *Grass Blades from a Cinnamon Garden, (This copy for Lucile Morrison)*, 1941; Phillips Library. FIGURE 24.

39. Illustrations from *Grass Blades from a Cinnamon Garden*; (each image 13.1 x 8.7 cm); all Amelia C. Dupin. FIGURES 11 a-d.

(a) *A Japanese Garden*, seal: *LMM*.

(b) *The Three-Foot Bamboo Pipe*, seal: *LMM*.

(c) *Palace Walls That Crown The Vale*, seal: *LMM*.

(d) *The Little Shrines on Quiet Hills*, seal: *LMM*.

40. *The Temple Lanterns*, monochrome frontispiece to *Lanterns by the Lake*, text by Joan Slavell Grigsby (published London: Kegan Paul, Trench, Trubner & Co; Japan: J. L. Thompson & Co, 1929); carved seal: *LMM*, (sheet 13 x 9.8 cm); University Research Library, UCLA. FIGURE 11.

**VII. WOODBLOCK PRINTS.**

41. *[Hunt For] The Scarlet Slipper*, 1920; seals: *LM, Matsumoto, Nishimura*; signed: *copyright 1920 by LM Miller, no. 31*; (sheet 23.5 x 14.0 cm); Private Collection. FIGURE 27.

42. *By The Little Green Gate, Korea*, 1920; seal: *LMM*, signed: *copyright 1920 by LM Miller, no. 230*, verso stamp: *By The Little Green Gate, Korea (Lilian Miller Oriental Woodcuts)*; (image 14.6 x 10.9 cm, sheet 15.8 x 12.5 cm, print trimmed on three sides, deckle edge on left); Private Collection. FIGURE 28.

43. *Monday Morning in Korea*, 1920; seal: *LMM*, signed: *copyright 1920, LM Miller, no. 200*; (image 20.1 x 11.5 cm, sheet 24.3 x 12.6 cm); (print no. 2 in a private collection has neither copyright nor signature but bears the seals *Matsumoto, Nishimura*); Amelia C. Dupin. FIGURE 29.

44. *Drying Red Peppers in Korea*, 1920; seal: *LMM*, signed: *copyright 1920 by LM Miller no. 155*, margin stamp: *Drying Red Peppers in Korea, Lilian Miller Oriental Woodcuts*; (image 22.5 x 17.7 cm, sheet 26.8 x 20 cm); (no. 35 bears the seals *Matsumoto, Nishimura, no. 98*, without a margin title and the copyright in the center, features some different color blocks to make the brushwood green and jars brown; prints numbered over 100, including no. 156 in the Honolulu Academy of Arts, all seem to feature the copyright and signature in the left corner); Private Collection. FIGURE 30.

45. *By the Great River Han*, 1920; seal: *LMM*, signed: *copyright 1920, by LM Miller, no. 47*; (image 23.4 x 16.6 cm, sheet 30.9 x 20.6 cm); Amelia C. Dupin. FIGURE 34.

46. *By the Great River Han* alternate edition (without woman in green robe), undated; seal: *LMM*, signed: *LM Miller*; (image 23.4 x 16.6 cm, sheet 30. 7 x 20.4 cm, deckle edge bottom); Private Collection. FIGURE 35.

47. *Orange-Sailed Junk of the Han*, 1920, box seal: *LMM*, signed: *copyright 1920 Lilian Miller no. 159*, border stamp: *Orange-Sailed Junk of the Han, Korea, Lilian Miller Oriental Woodcut*, handwritten *1928*; (image 46 x 23 cm, sheet 49.1 x 25.8 cm); (print no. 132 in the Honolulu Academy of Arts also bears the handwritten margin date 1928); Lilian Miller Collection, Scripps College. FIGURE 36.

48. *The Quaintness of Korea*, 1920; box seal: *LMM*, signed: *Lilian Miller*, (image 21 x 17.6 cm, sheet 23 x 17.6 cm, original mount in album with cover seal *LMM*); (a 1929 exhibition list gives edition A and edition B); Amelia C. Dupin. FIGURE 39.

49. *On the Way to the Brushwood Market, Korea*, 1921; rectangular box seal: *LMM*, signed: *copyright 1921 by LM Miller, no. 100*; (image 20.6 x 18.1 cm, trimmed); Amelia C. Dupin. FIGURE 38.

50. Untitled [Young Girl from the Back], undated; rectangular box seal: *LMM,* signed: *Lilian Miller;* (image 29.7 x 24.4 cm, original mount as a hanging scroll); Amelia C. Dupin. FIGURE 40.

51. *Moonrise Over Ancient Gateway, Korea,* 1920/21; seal: *LMM,* signed: *copyright 1921 by Lilian Miller, no. 127,* margin stamp: *Moonrise Over Ancient Gateway, Korea, Lilian Miller Oriental Woodcuts;* (image 31.8 x 19.3 cm, sheet 36.3 x 24.8 cm); (print no. 57 in a private collection bears no margin title, print no. 41 in a private collection, signed *LM Miller copyright 1920,* features an additional gray color block); Lilian Miller Collection, Scripps College. FIGURE 41.

52. *The Gateway of the Purple Hills,* Korea, 1921; square seal: *LMM,* oval seals: *Matsumoto, Nishimura,* signed: *copyright 1920 by LM Miller, no. 1;* (image 31.7 x 19 cm, sheet 34.6 x 22 cm); (this is the same as previous print except it is without moon and substitutes several different color blocks); Amelia C. Dupin. FIGURE 42.

53. *Tokyo Coolie Boy A* (gray sky with mica rain), 1920; rectangular seal: *LMM,* signed: *copyright 1920 by LM Miller, no. 217,* margin stamp: *Tokyo Coolie Boy A, Lilian Miller Oriental Woodcuts;* (image 27.4 x 12 cm, sheet 29.3 x 13.4 cm); Private Collection. FIGURE 32.

54. *Tokyo Coolie Boy B* (blue sky), 1928; rectangular seal: *LMM,* signed: *Lilian Miller 1928 no. 12,* margin stamp: *Tokyo Coolie Boy B, Kyoto;* (image 27.6 x 12. cm, sheet 29.3 x 13.5 cm); (another print bears the verso stamp: *Tokyo Coolie Boy B, blue, Miyako Hotel*); Private Collection. FIGURE 44.

55. *Father Kim of Korea* (yellow background), 1920; seal: *LMM,* signature: *copyright 1920 by LM Miller, no. 274,* margin stamp: *Father Kim of Korea, Lilian Miller, Oriental Woodcuts;* (image 13.6 x 16.1 cm, sheet 15.9 x 20.5 cm), (other prints bear the rectangular box seal *LMM* and are signed *Lilian Miller, 1928*); Private Collection. FIGURE 37.

56. *Father Kim of Korea* (blue background), 1928; rectangular box seal: *LMM,* signature: *Lilian Miller, 1928;* (image 18.7 x 21.2 cm, sheet 20.7 x 24.3 cm); Amelia C. Dupin. FIGURE 45.

57. *Father Kim on Muleback, Korea* (yellow background), 1928; carved rectangular box seal: *LMM,* signed: *Lilian Miller, 1928,* margin stamp: *Father Kim on Muleback, Korea;* (image: 27.6 x 31.2 cm, sheet 30 x 34 cm.); Amelia C. Dupin. FIGURE 46.

58. *Father Kim on Muleback, Korea* (blue background), 1928; carved rectangular box seal: *LMM,* signed: *Lilian Miller, 1928;* written on margin: *Father Kim on Muleback, Korea (edition B);* (image 27.5 x 31.1 cm, sheet 31 x 37.3 cm); Lilian Miller Collection, Scripps College. FIGURE 47.

59. *Morning Snow on Bamboo, Japan A* (gray background), 1920; box seal: *LMM,* signed: *copyright 1920 by Lilian Miller, no. 101,* margin stamp: *Morning Snow on Bamboo, Japan A;* (image 42.2 x 14.9 cm, sheet 44.7 x 17.5 cm); Pacific Asia Museum. FIGURE 27.

60. *Morning Snow on Bamboo, Japan B* (mica background), 1928; carved box seal: *LMM,* signed: *Lilian Miller, 1928,* margin stamp: *Morning Snow on Bamboo, Japan B;* (image 42.0 x 14.8 cm, sheet 44.2 x 16.9 cm); (also in the Honolulu Academy of Arts); Pacific Asia Museum. FIGURE 43.

61. *Hongkong Junk,* 1928; carved box seal: *LMM,* signed: *Lilian Miller, 1928,* margin stamp: *Hongkong Junk, Lilian Miller Oriental Woodcuts;* (image 34.5 x 24.1 cm, sheet 36.1 x 26 cm); (one print features a silver moon, and the print made as part of her public demonstrations does away with the moon altogether); Lilian Miller Collection, Scripps College. FIGURE 48.

62. *Diamond Mountains, Korea, Spring,* 1928; carved double box seal: *LMM,* signed: *Lilian Miller 1928,* margin stamp: *Diamond Mountains, Korea, Spring;* (image 21.1 x 35.8 cm, sheet 24.4 x 38.8 cm); Amelia C. Dupin. FIGURE 49.

63. *Diamond Mountains, Korea, Summer,* 1928; carved double box seal: *LMM,* signed: *Lilian Miller 1928,* margin stamp: *Diamond Mountains, Korea, Summer;* (image 21.1 x 35.8 cm, sheet 24.4 x 37 cm); Amelia C. Dupin. FIGURE 50.

64. *Diamond Mountains, Korea, Autumn,* 1928; carved double box seal: *LMM,* signed: *Lilian Miller 1928,* margin stamp: *Diamond Mountains, Korea, Autumn;* (image 21.1 x 35.8 cm, sheet 22.5 x 37.3 cm); (a print in the Honolulu Academy of Arts, Anonymous Gift, 1988 (20,102), also bears the stamp *Lilian Miller Oriental Woodcuts*); Amelia C Dupin. FIGURE 51.

**91**

65. *Diamond Mountains, Korea, Autumn Evening,* 1928; carved double box seal: *LMM,* signed: *Lilian Miller 1928,* margin stamp: *Diamond Mountains, Korea;* (image 21.1 x35.8 cm, sheet 22.5 x 37.3 cm); Private Collection. FIGURE 52.

66. *Diamond Mountains, Korea, Winter,* 1928; carved double box seal: *LMM,* signed: *Lilian Miller 1928,* margin stamp: *Diamond Mountains, Korea, Winter, Lilian Miller, Oriental Woodcuts,* (image 21.1 x 35.8 cm, sheet 22.5 x 37.3 cm); (a print in the Honolulu Academy of Arts is inscribed: *To Mr. Crandall on Christmas 1936*); Lilian Miller Collection, Scripps College. FIGURE 53.

67. *Diamond Mountains, Korea, Snowy Morning,* 1928; carved double box seal: *LMM,* signed: *Lilian Miller 1928,* margin stamp: *Diamond Mountains, Korea, Snowy Morning;* (image 21.1 x 35.8 cm, sheet 22.5 x 37.3 cm); Lilian Miller Collection, Scripps College. FIGURE 54.

68. *"The Crescent Moon Rides Low," Korea,* 1928; signed: *Lilian Miller, 1928;* margin: handwritten *"The Crescent Moon Rides Low," Korea;* (image: 20.5 x 31.9 cm, sheet 22.5 x 34 cm); Johnson Collection, Scripps College. FIGURE 55.

69. *Korean Farmhouse by Moonlight,* 1928, carved rectangular box seal: *LMM,* signed in red: *Lilian Miller, 1928,* margin stamp: *Korean Farmhouse in Moonlight;* (image 20.5 x 32 cm, sheet 23.1 x 35. 5 cm); (a print in a private collection bears the margin inscription *To Nuno-san with compliments of a Monday in _____!*); Lilian Miller Collection, Scripps College. FIGURE 56.

70. *Cathedral Cliffs, Diamond Mountains, Korea,* 1928; signed: *Lilian Miller, 1928,* margin stamp: *Cathedral Cliffs Diamond Mountains, Korea, Lilian Miller Oriental Woodcuts;* (image 36.3 x 24.2 cm, sheet 40 x 27.2 cm, deckle edge top and left); (other prints have the margin stamp in center and no deckle edge; a print in a private collection is mounted as a hanging scroll and bears this inscription on the back: *For Yoshihara-san, New Year's Day, Showa 9th year. In appreciation of his faithful and tireless service for three years, from Lilian Miller, Kyoto, Miyako Hotel*); Lilian Miller Collection, Scripps College. FIGURE 57.

71. *A Korean Shrine,* 1928; carved rectangular box seal: *LMM,* signed: *Lilian Miller, 1928,* margin stamp: *A Korean Shrine, Lilian Miller, Oriental Woodcuts;* (image 36.3 x 24.7 cm, sheet 38.9 x 27.5 cm); (also found in The British Museum and Honolulu Academy of Arts); Lilian Miller Collection, Scripps College. FIGURE 58.

72. *Nikko Gateway, Japan,* 1928; carved rectangular double box seal: *LMM,* signed: *Lilian Miller, 1928,* margin stamp: *Nikko Gateway, Japan, Lilian Miller Oriental Woodcuts;* (image 36.1 x 24. cm), sheet 39.4 x 26.8 cm); (print 1/11 is in a private collection, an unnumbered print is in the Honolulu Academy of Arts); Lilian Miller Collection, Scripps College. FIGURE 59.

73. *Makaen Monastery, Diamond Mountains, Korea,* 1928, carved box seal: *LMM,* signed: *Lilian Miller, 1928,* margin stamp: *Makaen Monastery, Diamond Mountains, Korea,* handwritten *Chicago Institute of Fine Art;* (image 25.3 x 37.5 cm, sheet 27.6 x 40.2 cm); (a print numbered 1/20 is in a private collection, there is also an unnumbered print in the Honolulu Academy of Arts with the margin inscription *In Chicago Art Institute*); Lilian Miller Collection, Scripps College. FIGURE 60.

74. *Autumn Evening, Korea,* 1928; box seal: *LMM,* signed: *Lilian Miller, 1928,* margin stamp: *Autumn Evening, Korea, Lilian Miller Oriental Woodcuts;* (image 21.7 x 43.2 cm, sheet 23.7 x 45.5 cm); (also in Honolulu Academy of Arts); catalog image: Lilian Miller Collection, Scripps College; exhibition: Patricia Lee Myers. FIGURE 61.

75. *Japanese Dwarf Plum Tree A* (black background, pink flowers), 1928; carved box rectangle seal: *LMM,* signature: *Lilian Miller, 1928,* margin stamp: *Japanese Dwarf Plum Tree, Lilian Miller Oriental Woodcuts,* handwritten *In Chicago Institute of Fine Arts;* (image 36.3 x 24.2 cm, sheet 39.3 x 27.3 cm); (a print in the Honolulu Academy of Arts bears the stamp *Japanese Dwarf Plum Tree A*); Lilian Miller Collection, Scripps College. FIGURE 62.

76. *Japanese Dwarf Plum Tree B* (gray background, white flowers), 1928; carved rectangular box seal: *LMM*, signature: *Lilian Miller, 1928, 1/12*, margin stamp: *Japanese Dwarf Plum Tree B, Lilian Miller Oriental Woodcuts*; (image 36.3 x 24.1 cm, sheet 39.6 x 27.4 cm); Private Collection. FIGURE 63.

77. *Japanese Dwarf Pine Tree A* (black background), 1928; carved rectangular box seal: *LMM*, signature: *Lilian Miller, 1928*, margin stamp: *Japanese Dwarf Pine Tree A, Lilian Miller Oriental Woodcuts*; (image 36.2 x 24.1 cm, sheet 39.5 x 26.2 cm); Lilian Miller Collection, Scripps College. FIGURE 64.

78. *Japanese Dwarf Pine Tree B* (tan background), 1928; rectangular box seal: *LMM*, signature: *Lilian Miller, 1928*, margin stamp: *Japanese Dwarf Pine Tree, Lilian Miller Oriental Woodcuts*; (image 36.2 x 24.1 cm, sheet 39.5 x 26.2 cm); Amelia C. Dupin. FIGURE 65.

79. *Japanese Dwarf Berry Tree* (black background), 1928; carved rectangular box seal: *LMM*, signature: *Lilian Miller, 1928*, margin stamp: *Japanese Dwarf Berry Tree, Lilian Miller Oriental Woodcuts*; (image 28.7 x 21.3 cm, sheet 34.3 x 25.5 cm); Private Collection. FIGURE 66.

80. *Japanese Dwarf Berry Tree*, variation copy (gray *gomazuri* background and black border for tree trunk), undated; margin: handwritten in red *variation copy, LMM*; (image 28.7 x 21.3 cm, sheet 34.3 x 25.5 cm); Lucille Lee Roberts. FIGURE 67.

81. *Rainbow Phoenix Waterfall, [Diamond Mountains, Korea]*, 1928; carved box seal: *LMM*, signed: *Lilian Miller, 1928*, margin stamp: *Rainbow Phoenix Waterfall, Lilian Miller Oriental Woodcuts*; (sight image 38.3 x 24.8 cm, sheet 39.3 x 27.8 cm); (a print in a private collection is no. 1/11, an unnumbered print is in the Lilian Miller Collection, Ruth Chandler Williamson Gallery, Scripps College); Private Collection. FIGURE 69.

82. *Garden Gate, Omori Japan*, 1928; carved rectangular box seal: *LMM*, signature: *Lilian Miller, 1928*, margin stamp: *Garden Gate, Omori Japan*; (round image 29.6 x 29.9 cm, sheet 33.9 x 34.4 cm); Private Collection. FIGURE 71.

83. *Rain Blossoms, Japan A* (gray), 1928; carved rectangular box seal: *LMM*, signature: *Lilian Miller, 1928*, margin: handwritten *"Rain Blossoms," Japan, Edition A*; (image 24.1 x 36.3 cm, sheet 26.1 x 39.4 cm); (there is also a print in the Honolulu Academy of Arts); Lilian Miller Collection, Scripps College. FIGURE 72.

84. *Rain Blossoms, Japan, B* (brown), 1928; carved rectangular bx seal: *LMM*, signature: *Lilian Miller, 1928*, margin: handwritten *"Rain Blossoms," Japan, Edition B*; (image 25.7 x 38 cm); Private Collection. FIGURE 73.

85. *Korean Junks at Sunset, diptych*, 1928; carved box seal: *LMM*, signed: *Lilian Miller, 1928*, margin stamp: *Korean Junks at Sunset, Lilian Miller Oriental Woodcuts*; (each image 36 x 37.7 cm, each sheet 39.4 x 41.3 cm); (the left print is found in the Lilian Miller Collection, Scripps College); Honolulu Academy of Arts, Anonymous Gift, 1988 (20,104). FIGURE 75.

86. *Inland Sea, Japan*, 1928; carved box seal: *LMM*, signature: *Lilian Miller, 1928*, margin stamp: *Inland Sea Japan, Lilian Miller Oriental Woodcuts*; (image 19.6 x 49.9 cm, sheet 20.5 x 51.3 cm); (a print in a private collection bears the margin inscription *Edition copy—LMM*; all surveyed copies have a margin smudge); Private Collection. FIGURE 76.

87. *Moonlight on Fujiyama, Japan*, 1928; carved rectangular box seal: *LMM*, signed: *Lilian Miller, 1928*, margin stamp: *Moonlight on Fujiyama, Japan*; (image 37.5 x 51.8 cm, sheet 41.8 x 54.8 cm); (also in the Honolulu Academy of Arts); catalog: Lilian Miller Collection, Scripps College; exhibition: Patricia Lee Myers. FIGURE 77.

88. *Sunrise at Fujiyama, Japan*, 1928; carved rectangular box seal: *LMM*, signed: *Lilian Miller, 1928*, margin stamp: *Sunrise on Fujiyama, Japan, Lilian Miller Oriental Woodcuts*; (image 37.3 x 51.6 cm, sheet 38.6 x 54.8 cm); catalog: Lilian Miller Collection, Scripps College; exhibition: Patricia Lee Myers (unsigned and undated). FIGURE 78.

89. *Moonlight on Mt. Fuji*, undated; signed: *Lilian Miller*, margin: handwritten *Moonlight on Mt. Fuji*; (image 24.2 x 36.3 cm, sheet 27.7 x 40 cm); (the print in the Honolulu Academy of Arts is unsigned); Lilian Miller Collection, Scripps College. FIGURE 79.

90. *Sanpans at Sunset, Japan*, 1934; margin: handwritten *Sampans at Sunset, Lilian Miller*; (image 27.4 x 24 cm, sheet 33 x 27 cm, deckle edge top and left); (a print in the Honolulu Academy of Arts bears the signature *Lilian Miller, 1934*); Lilian Miller Collection, Scripps College. FIGURE 80.

91. *The Little White Plum Blossom Tree*, undated; carved box seal: *LMM*, margin: handwritten *The Little White Plum Blossom Tree, by Lilian Miller*; (image 28.2 x 29 cm, sheet 30.8 x 31.8 cm, deckle edge right and top); (other prints show considerable variations in printing with the blue on the box being darker at top then lighter at bottom, or the reverse shading); Lucille Lee Roberts. FIGURE 81.

92. *Rain in the Willows*, undated; carved rectangular box seal: *LMM*, signed: *Lilian Miller*, margin: handwritten *Rain in the Willows*; (image 25.7 x 18.2 cm, sheet 27.7 x 19.8 cm); Private Collection. FIGURE 82.

93. *Blue Hills and Crescent Moon*, 1934/1935; margin: handwritten *Blue Hills and Crescent Moon, By Lilian Miller*; (image 24.0 x 35.4 cm, sheet 27.2 x 38.8 cm) (a print in a private collection is signed *Lilian Miller, 1934*, another is signed *Lilian Miller, 1935*, there is an unsigned and undated print in the Honolulu Academy of Arts); Private Collection. FIGURE 83.

94. *Mountain Lake at Dawn, undated*; signed: *Lilian Miller*; margin: handwritten *Mountain Lake at Dawn*; (image 30.0 x 44 cm, sheet 33.2 x 47.3 cm); Private Collection. FIGURE 84.

95. *Moonrise Over a Kyoto Hillside*, 1934; signed: *Lilian Miller, 1934*, margin: handwritten *Moonrise Over a Kyoto Hillside*; (image 17.5 x 24 cm, sheet 19.2 x 26.1 cm); Private Collection. FIGURE 85.

96. *Pagoda at Dusk, Kyoto* (small), 1934; carved rectangular box seal: *LMM*, signed: *Lilian Miller, 1934*, margin: handwritten *Pagoda at Dusk, Kyoto*; (image 12 x 31.8 cm, sheet 14.1 x 34.2 cm); Private Collection. FIGURE 86.

97. *Pagoda at Dusk* (large), undated; carved rectangular box seal: *LMM*, signed: *Lilian Miller*, margin: handwritten *Pagoda at Dusk, Edition B*; (image 15.1 x 35.8 cm, sheet 17.7 x 38.1 cm); Robert and Marilyn Ravicz gift, Scripps College. FIGURE 87.

98. *Drum Tower, Nikko Japan*, undated; carved rectangular box seal carved on block: *LMM*, margin: handwritten *Drum Tower, Nikko, By Lilian Miller*; (image 36.6 x 21 cm, sheet 39.6 x 26.9 cm, deckle edge top and left); (also found in the Honolulu Academy of Arts); Private Collection. FIGURE 89.

99. *Festival of Lanterns, Nara*, undated (ca. 1934); carved rectangular box seal: *LMM*, margin: handwritten *Festival of Lanterns, Nara, by Lilian Miller*; (image 36.5 x 15.1 cm, sheet 38.7 x 17.3 cm); Lilian Miller Collection, Scripps College. FIGURE 90.

100. *Nanzenji by Moonlight*, 1934; carved rectangular box seal: *LMM*, margin: handwritten *Nanzenji by Moonlight, by Lilian Miller*; (image 12 x 31.8 cm, sheet 14.1 x 34.2 cm); (the print in the Honolulu Academy of Art bears the margin inscription *Nanzenji Temple at Moonlight, Kyoto*, a print in a private collection bears the dated signature *Lilian Miller, 1934*); Lilian Miller Collection, Scripps College. FIGURE 92.

101. *Snow on Temple Roofs* (blue sky), undated; carved rectangular box seal carved into block: *LMM*, margin: handwritten *Snow on Temple Roofs, Lilian Miller*; (image 24.3 x 33.2 cm, sheet 26.8 x 35.7), (also in the Honolulu Academy of Arts); Lilian Miller Collection, Scripps College. FIGURE 93.

102. *Snow on Temple Roofs* (gray sky), undated (ca. 1934); carved rectangular box seal: *LMM*; (image 24.3 x 33.2 cm, sheet 26.8 x 35.7); (also in the Honolulu Academy of Arts); Lilian Miller Collection, Scripps College. FIGURE 94.

103. *Torii Leading to Fox Shrine*, undated (1935); carved rectangular box seal: *LMM*, margin: handwritten *Torii Leading to a Fox Shrine, by Lilian Miller*; (image 27.3 x 22.2 cm, sheet 30.2 x 24.3 cm); (a print in a private collection bears at left the signature *Lilian Miller, 1935* and the inscription: *For Carrie, with my best, Feb. 1936, LMM*; another bears only the signature at right *Lilian Miller*); catalog Lilian Miller Collection, Scripps College; exhibition: Patricia Lee Myers. FIGURE 95.

104. *Lantern on a Hill, Nikko, Autumn*, 1934; carved rectangular box seal: *LMM*, signed: *Lilian Miller, 1934*, margin: handwritten *Lantern on a Hill, Nikko, Autumn*; (circular image 25.2 x 25.2 cm, sheet 27.0 x 26.7 cm); (also found in the Honolulu Academy of Arts); Private Collection. FIGURE 96.

105. *Lantern on a Hill, Nikko, Spring*, 1934; carved rectangular box seal: *LMM*, signed: *Lilian Miller, 1934*, margin: handwritten *Lantern on a Hill, Nikko, Spring*; (circular image 25.2 x 25.2 cm, sheet 27.0 x 26.7 cm); (also found in the Honolulu Academy of Arts); Private Collection. FIGURE 97.

106. *A Kyoto Garden at Azalea Time*, 1935; signed: *Lilian Miller, 1935*; margin: handwritten *A Kyoto Garden at Azalea Time*; (image 27.8 x 18.8 cm, sheet 31.1 x 22 cm, deckle edge top and left); Private Collection. FIGURE 98.

107. *East Mountain, Kyoto, Sunrise*, undated; signed: *Lilian Miller*, margin: handwritten *East Mountain, Kyoto, Sunrise*; (image 26.7 x 23.8 cm, sheet 30.9 x 27.3 cm); Lilian Miller Collection, Scripps College. FIGURE 99.

108. *East Mountain, Kyoto, Dusk*, undated; signed: *Lilian Miller*, margin: handwritten *East Mountain, Kyoto, Dusk*; (image 26.7 x 23.8 cm, sheet 30.9 x 27.3 cm); Lilian Miller Collection, Scripps College. FIGURE 100.

## VIII. LITHOGRAPHS AND LITHOTINTS.

109. *Pines of the Heights*, 1938, lithotint; rectangular box seal: *LMM*, signed: *Pines of the Heights, 1935??, 100/1, This first print of this first lithotint edition in Honolulu, presented to the Honolulu Academy of Arts with deepest appreciation, Lilian Miller, April 1938*; (image 41.6 x 35.7 cm, sheet 56.5 x 37.8 cm); Honolulu Academy of Arts, Gift of Lilian Miller, 1938 (10,978). FIGURE 21.

110. *Study in Black and Silver*, 1938, lithotint; seal: *LMM*, signed: *Lilian Miller, 1938, Study in Black and Silver*; (image 26 x 36.5 cm, sheet 30.5 x 49.2 cm); Honolulu Academy of Arts, Gift of Mrs. Theodore A. Cooke, 1938 (11,132). FIGURE 104.

111. *Black Bamboo*, 1938; (image 37 x 39.7 cm, sheet 41.4 x 48.3 cm); Honolulu Academy of Arts Purchase, 1938 (11,133). FIGURE 105.

112. *Spray of Bamboo*, 1938, lithotint; seal: *LMM*, signed: *Lilian Miller, 1938*; made for 10th annual exhibition of the Honolulu Print Makers in an edition of 100, 1938; (image 22.6 x 35.6 cm, sheet 33.8 x 47 cm); Honoulu Academy of Arts, Gift of Honolulu Print Makers, 1946 (12,269). FIGURE 20.

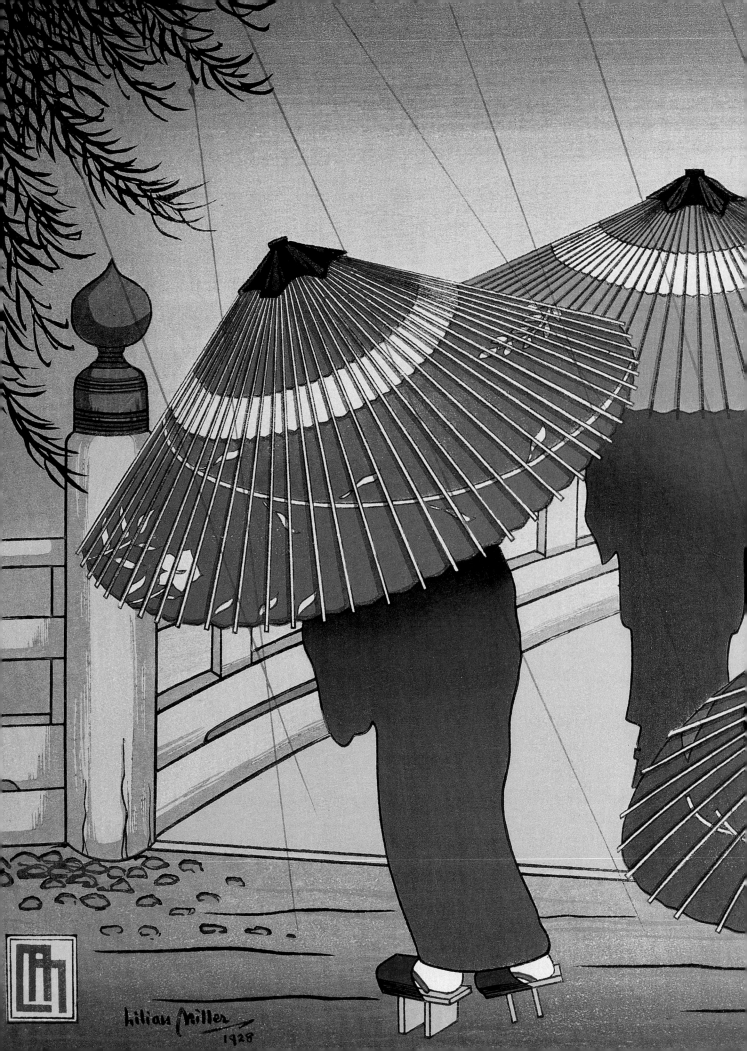

Lilian Miller
1928